IMAGES
of America

THE GREAT CHICAGO FIRE

IMAGES
of America

THE GREAT CHICAGO FIRE

John Boda and Ray Johnson

ARCADIA
PUBLISHING

Published by Arcadia Publishing
Charleston, South Carolina

Printed in the United States of America

Library of Congress Control Number: 2017949328

For all general information, please contact Arcadia Publishing:
Telephone 843-853-2070
Fax 843-853-0044
E-mail sales@arcadiapublishing.com
For customer service and orders:
Toll-Free 1-888-313-2665

Visit us on the Internet at www.arcadiapublishing.com

We dedicate this book to the memory of all those who lost their lives, to all the thousands affected who had to rebuild their lives and city, and to all the heroic first responders who did the best job they could do and no doubt saved many lives and prevented this disaster from becoming even worse than it was.

CONTENTS

ACKNOWLEDGMENTS

Only nine years after the Great Chicago Fire, around 1880, my great-great grandfather Edward Bohn came from Germany and was one of thousands of immigrants who settled in Chicago near the Union Stockyards during the accelerated growth period after the fire. His granddaughter (my grandmother), Anna Bohn, was one of 2,500 people who boarded the *Eastland* steamship on the morning of July 24, 1915, docked between Clark and LaSalle Streets on the Chicago River. At 7:30 a.m., it capsized, and 844 lives were lost, including all members of 22 entire families, making it Chicago's worst and deadliest disaster. My grandmother somehow survived, and that event, and my personal connection to it, ignited a flame of deep interest in all things relating to Chicago history, which are often closely connected in many ways. I have had a long interest in the Great Chicago Fire and continue to research, explore, and teach the history of that event, which never seems to cease revealing new insight and revelations!

I wish to thank Brian Petronio, assistant store manager of Barnes & Noble in Bolingbrook, Illinois, for his encouragement and initial idea for me to pursue the course that resulted in this book. Thanks also to Katelyn and all the fine people at Arcadia Publishing and their commitment to preserving local history all over America. Thanks to Ray Johnson, Chicago's history cop, for his partnership. Lastly, thanks to my wife, Maureen, who always encourages me to pursue my dreams and interests and understands that I never have too many books, just not enough shelves.

—John Boda

I would like to thank the following for their gracious assistance: Jordyn Cox, Sarah and Leslie Martin of the Chicago History Museum, Laura Kraly and Jeanette Weiden of the Loutit District Library, Julius Machnikowski and Phil Costello of the Cook County Clerk of the Circuit Court Archives, Glenn Longacre and Doug Bicknese of the Great Lakes Region of the National Archives, John Powell of the Newberry Library, the staff of the Special Collections Department of the Chicago Public Library, Geoffrey Reynolds of the Joint Archives of Holland, Mark Fedder of the Manistee County Historical Museum, and the staff and volunteers of the Peshtigo Fire Museum.

I would also like to thank John Boda for his encouragement and love of history, and a huge hug for my wife, Laurie, and sons Mikey and Kevin who put up with seeing the back of my head a lot!

—Raymond Johnson

All photographs, unless otherwise credited, are courtesy of the New York Public Library.

INTRODUCTION

The Great Chicago Fire, which occurred October 8–10, 1871, has risen to mythological proportions, and many now find it difficult to separate fact from fiction. When most people are asked about it, the usual and most common "fact" is that it was started by Catherine O'Leary and her cow kicking over a lantern. But Catherine O'Leary herself stated she went to bed early that night, approximately an hour before the fire even started, and that was corroborated by her neighbors. She became the scapegoat for the fire, and afterwards she hated the notoriety. In defiance, she stated that her "likeness," or picture, would never be found, in an effort to deny history the chance of connecting her with the fire. Although she was successful in denying history of any photographs of herself, she was not successful in dodging the blame, which continues today. The official conclusion reached by the City of Chicago, which remains to this day, is that the fire did indeed start in the O'Leary barn at 137 South DeKoven Street, but how it started is unknown and remains a mystery.

In chapter three, we offer a possible alternate theory, which continues to gain acceptance, as to the cause of the fire. If this theory is true, then whatever caused the spark on the ground to ignite is irrelevant, whether it was a cow kicking over a lantern, a man lighting a cigarette, or somebody simply lighting a match. We caution that this theory does not offer conclusive evidence of the cause of the fire, but it is a possible theory of what could have caused several firestorms to occur on the same night in a large three-state area in the shape of a triangle.

Another seldom-heard mystery about this disaster is that there is not one actual photograph today of the Great Chicago Fire while it was burning. It is believed there were people taking pictures during the fire itself, but either the intense heat destroyed the photographs amid the chaos, the photographers lost their lives (and pictures) in the process, or they simply got lost through time. But there are many photographs of Chicago just before and after this great event and those are the majority of the pictures published in this book. We have assembled here a valuable record of what really happened in the Great Chicago Fire.

Chicago had developed into a major city by 1871. It started as a town in 1833, and in those 38 years, it rapidly grew from 350 residents to 300,000 living within the boundaries of a city six miles long north to south and three miles wide from the lake to the west. Even though some of the buildings were brick or limestone, most of the roofs were wood or tar and vulnerable to sparks and flame. It is estimated that of the city's 60,000 buildings, more than 40,000 were made completely of wood. Many miles of Chicago sidewalks and streets were laid in wood-tar blocks, which easily became engulfed in the flames when they came.

Being October, many people stockpiled lumber for burning through the winter, and it is a well-known fact that Chicago had just experienced one of the driest summers on record, with very little rainfall.

Fires were commonplace in Chicago at that time, and many residents welcomed them as a form of entertainment as they gathered in the street to watch the flames. Many even did that with

this fire at first, but they began to realize that this was no ordinary fire and soon were running for their lives.

By 1863, there were 186 reported fires in Chicago; by 1868, that number rose to 515. By 1870, the record states a total of 600 fires occurred in Chicago.

By 1871, the Chicago Fire Department was large and considered very modern for the day, but it was also spread too thin, with 185 firefighters covering 18 square miles. The city had an elaborate system of 172 fire alarm boxes, which sent telegraphs to the watchman lookout at the courthouse. The city had a network of water mains and hydrants pumping water from the new waterworks station.

All this was sufficient for ordinary fires, but this was no ordinary fire; it was fueled by 30 mile-per-hour winds, and precious time was wasted by various blunders at the start. It was summarized by one Chicago firefighter at that time, who said, "It seemed everything was against us."

The photographs here reveal the depth and scope of this disaster, which destroyed 2,000 acres and 18,000 buildings and left nearly 100,000 people homeless. It killed approximately 300 people, and identifying bodies was extremely difficult as the few found were burned beyond recognition. Most were never recovered.

Jonas Hutchinson was a notary public with an office at 86 Washington Street in Chicago. On October 9, 1871, while the city was in flames five miles from his residence, he wrote his mother in New Hampshire: "We are in ruins. All the business portion of the city has fallen prey to the fiery fiend. Our magnificent streets for acres and acres lined with elegant structures are a heap of sightless rubbish. It cannot be described."

The photographs that are published here will tell the story of this disaster.

One

PREFIRE CHICAGO

In August 1833, a small group of settlers assembled in the Sauganash Hotel to sign papers to incorporate this small, swampy village of 150 people officially as the town of Chicago. By the end of that year, the population swelled to about 250 settlers, outnumbered greatly by local Indians and wolves. But even in spite of all the disadvantages, it grew and grew rapidly. By 1871, it was being called "The Metropolis of the West," with 335,000 residents, and largely thanks to its first mayor, William B. Ogden, Chicago was the central hub for all of the country's railroads. But growing so fast caused many buildings to be constructed in the quickest and cheapest way, out of wood and tar. Most of the streets and sidewalks were paved in wood blocks, and even many of the "fireproofed" structures of brick and steel had tar roofs, which proved fatal in the Great Chicago Fire. It was estimated there were over 55 miles of pine-blocked streets and 600 miles of wooden sidewalks in Chicago by October 1871.

On Saturday, October 7, 1871, the night before the Great Chicago Fire began, the entire fire department was called out to fight a fire; it was finally stopped but not before it consumed four city blocks. It caused a heavy toll on the firemen and damaged some equipment amid the 16-hour battle. Chicago residents were relieved come morning that what almost became "The Great Fire" was under control. But the *Chicago Tribune* printed a prophetic warning in the paper that very day, October 8, 1871: "The absence of rain for three weeks has left everything in so flammable condition that a spark might set a fire which would sweep from end to end of the city." Later that night, the real Great Chicago Fire would begin around 9:00 p.m. in the barn of the O'Leary family at 137 South Dekoven Street.

Chicago is now forever divided into "pre-fire" and "post-fire" timelines. The following pictures are a look into the city before the fire and set the stage of the storm coming on October 8–9, 1871.

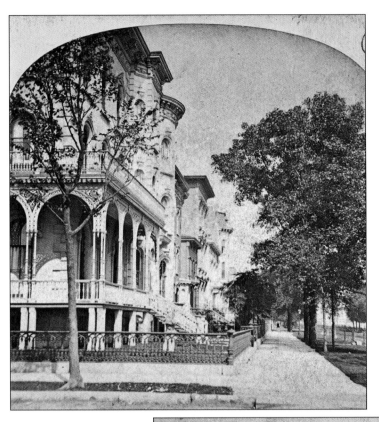

This view of the city, looking north, shows the west side of Michigan Avenue from Adams Street. It gives an idea of the wealth of the residents in this area of the city before the fire. Even after the fire, the area remained primarily residential. One of the reasons that the 1893 World's Columbian Exposition was held in Jackson Park and not near Lake Park (now Grant Park) is that organizers did not have the support of the residents who were living close to the proposed fairgrounds. The current Art Institute Building is now across Michigan Avenue from where this photograph was taken.

Booksellers Row was at 111–123 State Street, on the east side between Washington and Madison Streets. The Western News Company, S.C. Griggs & Company, and W.B. Keen & Cook also had businesses here. It was a great cultural blow to the city when Booksellers Row was lost in the fire.

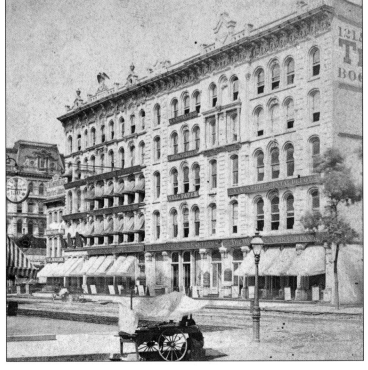

The Chamber of Commerce Building sat at the southeast corner of LaSalle and Washington Streets. It was three stories tall and was designed by Edward Burling. The building was dedicated on August 30, 1865. The fence across the street surrounded the city courthouse. First Baptist Church originally used this location.

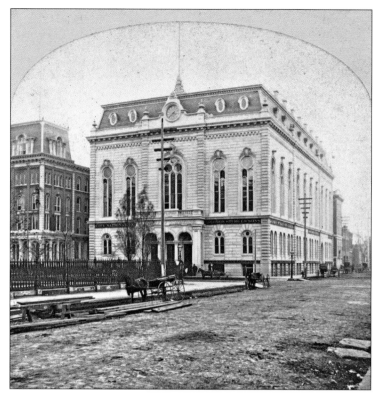

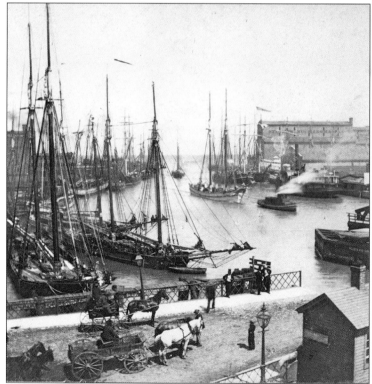

There is no longer a Rush Street Bridge that crosses the Chicago River. In this picture of the old bridge, the mouth of the Chicago River can clearly be seen. This photograph also illustrates what a major port of call Chicago was and the amount of boat traffic and shipping that took place.

This is a great view of the State, Clark, and Fifth Avenue (now Wells Street) Bridges over the Chicago River. Many of the bridges were destroyed during the fire. They were the old pivot-style swing bridges. Most people fled across these bridges toward Lake Michigan, and when the bridges became too crowded or burned, many tried the under-river tunnels at LaSalle and Washington Streets to get to the lake. These are now sealed and not in use today.

This photograph of the Clark Street Bridge shows how the bridge and sidewalks were made of wood, which contributed to the ease of the great fire spreading across the river twice. This area near Clark Street would witness another disaster in 1915, when the SS *Eastland* capsized and 844 lives were lost.

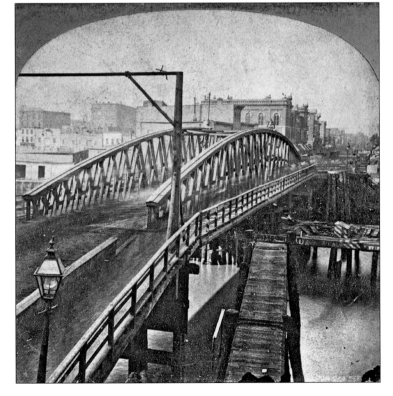

The Chicago City Courthouse, at the corner of Clark and Randolph Streets, was built in 1853 by Chicago's first architect, John Van Osdel. The two-story tower housed a 24-hour fire watch sentinel, and the 5.5-ton bell would ring loudly to warn people of flames. The building was considered "absolutely fireproof," but when the fire came, it burned, and the bell came down in a loud crash heard miles away.

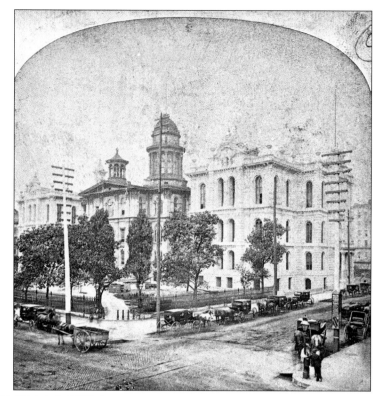

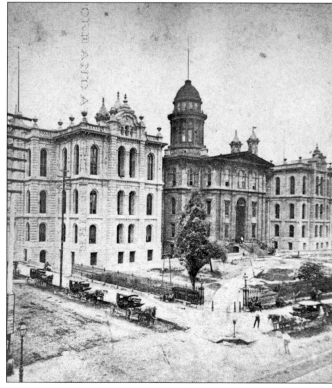

This photograph of the courthouse shows the east and west wings that were added after the Civil War. The jail was in the basement of the building, and there was a long-standing ghost story about the "Spirit of the Jail." Loud wails were heard from the outside of the jail, purportedly from the spirit of an individual who was hung in 1865.

13

Crosby's Opera House faced Washington Street with an entrance on State Street. It was built in 1865 as a Chicago gem, seating 2,500 people, but its opening was delayed due to Abraham Lincoln's assassination. All through the summer of 1871, it had been closed for extensive remodeling, with the grand reopening date set for Monday, October 9, 1871, the very same day it burned down in the Great Chicago Fire.

This view of Dearborn Street north of Lake Street shows how much of the wholesale and commercial business of the city was in the blocks just south of the Chicago River. After the fire, the office work would move south to what is now the central Loop, and the area shown here would become important to the produce industry.

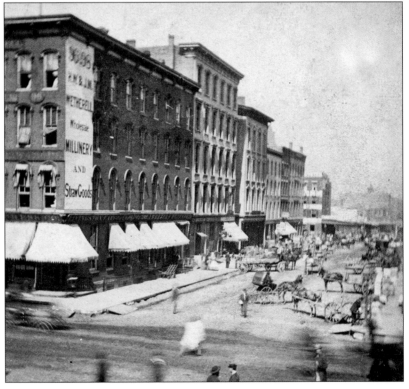

14

It is unclear where this department store picture was taken; however, it is likely Lake Street, because according to *Andreas' History of Chicago*, Clayburgh & Einstein opened at 27 Lake Street and remained at that location until it was burned out in the fire.

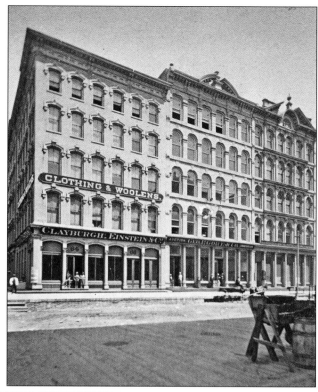

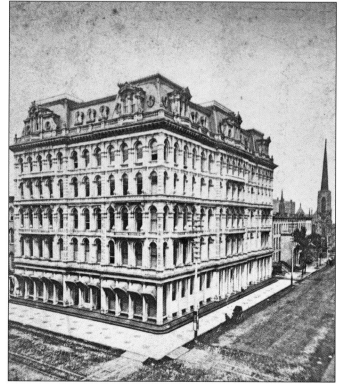

The Field, Leiter & Company Building was finished in 1868 and stood at the northeast corner of State and Washington Streets. It was known as Potter Palmer's "Marble Palace." The partners of Field, Leiter & Company at the time of the building's erection were Marshall Field, L.Z. Leiter, Henry Field, H.J. Walling, and L.G. Woodhouse. The building stood on the same location as Macy's department store (formerly Marshall Field's).

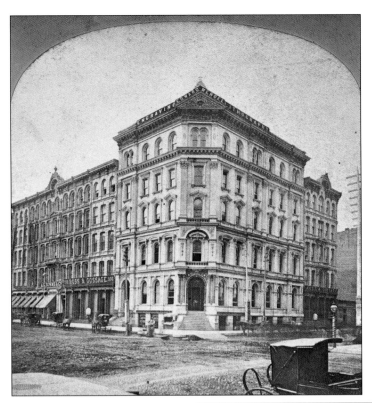

The First National Bank Building stood at the southwest corner of State and Washington Streets. The building was five stories high, and the architects were Burling & Whitehouse. It became one of the most prominent banks in the city, and Lyman J. Gage, who eventually became president of the board of directors of the 1893 World's Columbian Exposition, was a president of the bank. The building was partially destroyed in the fire but all of its notes, securities, and records survived.

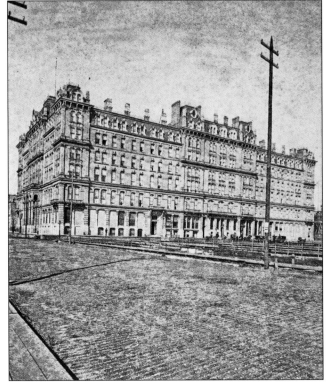

The Grand Pacific Hotel covered an entire block of Quincy, Jackson, Clark, and LaSalle Streets. Costing over $600,000, it was nearly completed—with only the roof to be finished—when the fire destroyed it. Ironically, the state-of-the-art building was designed to be fireproof, with tanks under the new roof holding 12,000 gallons of water to flood any part of the structure at a moment's notice in case of fire. Unfortunately, they were empty when the fire started, as the building was not yet open.

The Grand Pacific Hotel was a six-story structure designed by architect W.W. Boyington. Pictured is the interior of the first building, which was destroyed by the fire. The second building was constructed on the same foundation using the same architect. It was later destroyed to make room for the Continental Bank Building, which stands on the site today.

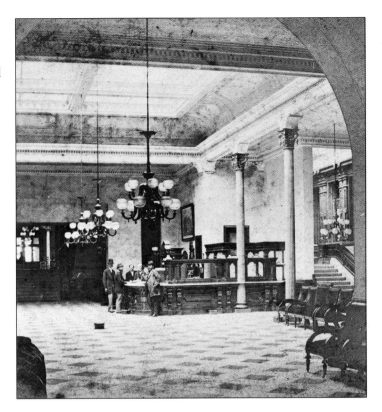

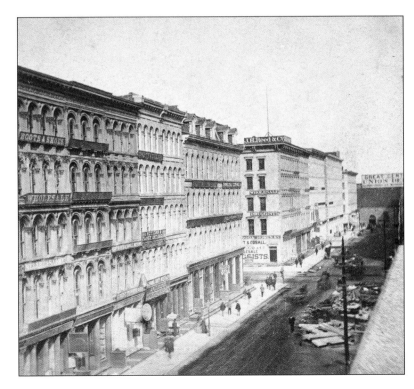

This view of Lake Street looking east from State Street shows that it comes to an end at the Great Central Union Depot, which was one of two predecessors to the current Union Station. The depot was destroyed by the fire.

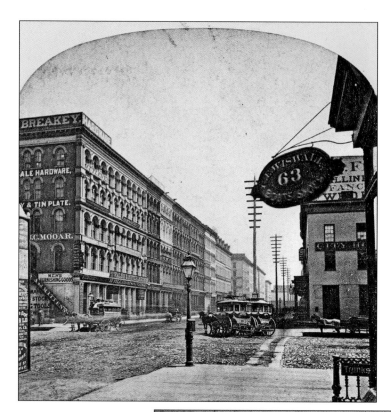

In this view of Lake Street looking east from State Street, the Boots Store of Charles E. Wiswall at 63 Lake Street can be seen. Across Lake Street to the north and on the northeast corner of Lake and State Streets is the business of Walsh & Hutchinson millinery and straw goods store. It was at 58–60 Lake Street and was owned by James Walsh and Thomas Hutchinson.

This view of Lake Street looking east from Clark Street shows just how large of a commercial area this was before the fire. Haberdasheries, furriers, millineries, and druggists are just some of the establishments lining the north side of the street.

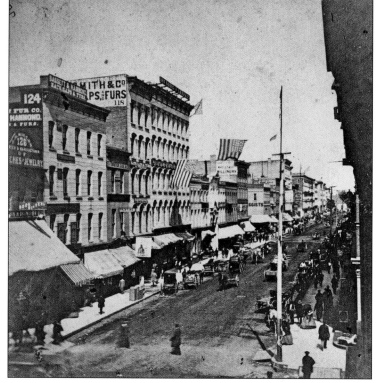

This view of LaSalle Street looking north would have been taken from the area of Arcade Court, which was more of an alleyway between Monroe and Madison Streets. Following the street north for three blocks would lead to the courthouse and Board of Trade Building along Washington Street.

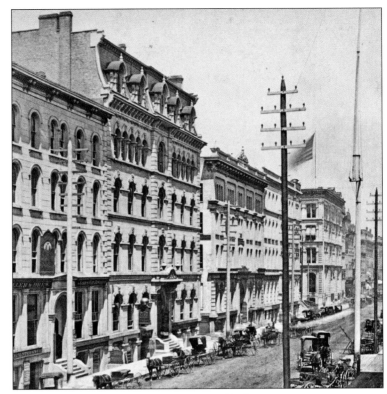

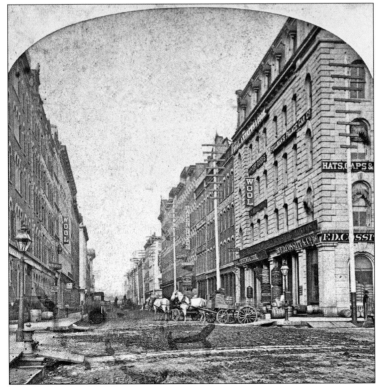

This is a view of Michigan Avenue looking north from Randolph Street. Three blocks farther north was the site of Fort Dearborn. Looking left, one would have seen Dearborn Park, which would become the site of the Chicago Public Library, now the Chicago Cultural Center. To the right would have been the site of today's Millennium Park.

In this view of North Clark Street from the foot of the bridge, note the stark contrast between the wood frame buildings and the newer brick construction (most claiming to be fireproof) farther south. There would be very little left in the city that could claim to be truly fireproof. The foreground up to the first cross street is now all the east-west streets of lower and upper Wacker Drive.

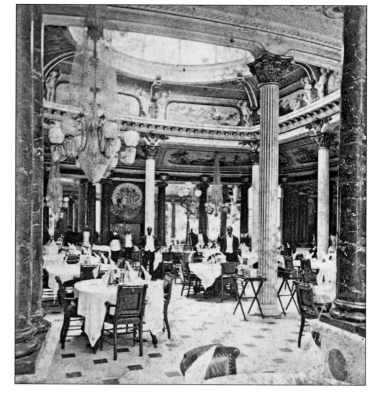

This dining room was in the renowned Palmer House at the southeast corner of State and Monroe Streets. Legend has it that after the hotel burned down, Potter Palmer became depressed and assumed his new wife, Bertha, would leave him. When he talked with her about it, she purportedly said, "You still owe me a hotel!"

Wealthy businessman Potter Palmer was 45 years old in 1871 and had just married 22-year-old Bertha Honoré. As a wedding gift, he gave her a brand-new glorious grand hotel—the Palmer House. At seven stories, it was the tallest building in Chicago before the fire, and Palmer billed it as the "only fireproof hotel in America." But 13 days after the grand opening, Palmer House went up in flames in the Great Chicago Fire on Monday, October 9, 1871. After losing the house and nearly everything else, he borrowed $2 million on his good name and quickly rebuilt on an even grander scale after the fire.

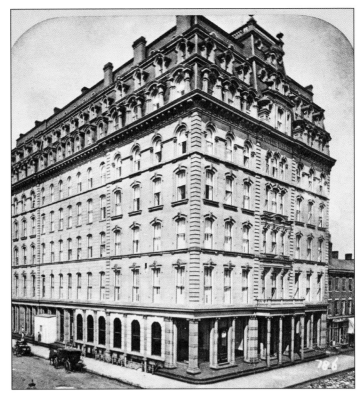

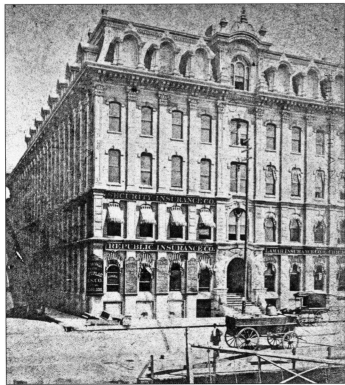

The Republic Life Insurance Company Building was at 157–163 LaSalle Street between Madison and Monroe Streets. Its secretary was Owen E. Moore, its vice president was A.W. Kellogg, and its president was John V. Farwell. Farwell was an early partner of Marshall Field. By 1870, John Farwell was doing about $10 million in annual sales in his own wholesale dry goods business.

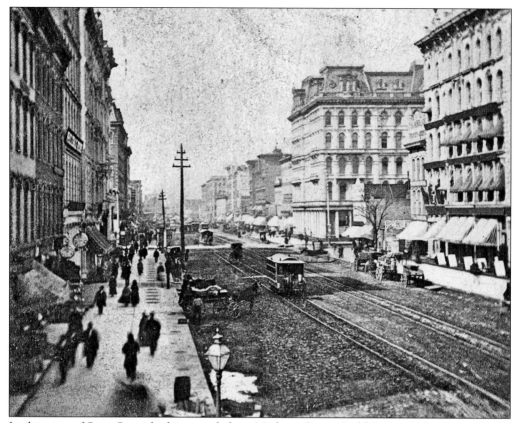

In this view of State Street looking north from Madison Street, Field, Leiter & Company can be seen at the northeast corner of State and Washington Streets. Across Washington Street to the south is Bookseller's Row at 111–123 State Street. The Field, Leiter & Company store occupied the location where the current Macy's (former Marshall Field's) stands today.

Terrace Row was erected in 1856 and was designed by architect W.W. Boyington. These limestone-faced, four-story townhouses were meant for upscale residents. The residences were priced at between $18,000 and $30,000 each. They were located on the west side of Michigan Avenue, south of Van Buren Street. The Auditorium Building currently occupies this space.

Tremont House (Hotel) is currently located at 100 East Chestnut Street and is the fifth version of this Chicago landmark. The first Tremont was built in 1839 only two years after Chicago incorporated as a city and was located on the southeast corner of Lake and Dearborn Streets until it was destroyed in a fire. The second hotel, on the same corner, also burned down. This photograph shows the third hotel, designed by architect John M. Van Osdel. It also fell to flames, in the Great Chicago Fire in October 1871.

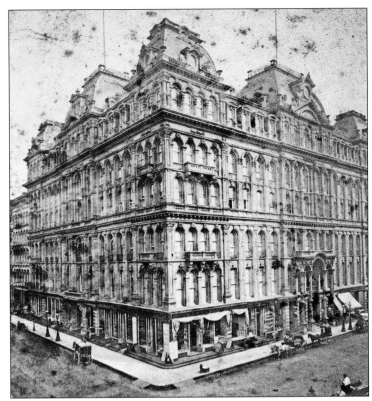

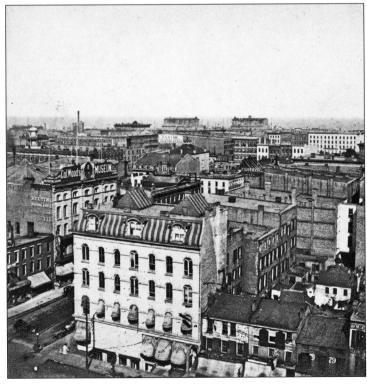

This was the view looking northeast from the dome of the courthouse. The intersection to the lower left is Clark and Randolph Streets. The second building on the north side of Randolph Street is what became known as Colonel Wood's Museum. The museum was a cross between an art museum, theater, and carnival sideshow.

23

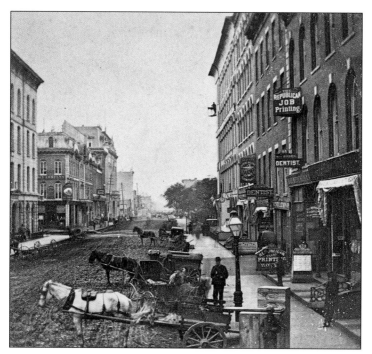

Standing on Dearborn Street looking west down Washington Street, this was the view prior to the great fire. Today, all of the buildings on the right, up to the trees, are gone, and the open Daley Plaza has taken their place. The Chamber of Commerce Building can be seen at the southeast corner of LaSalle and Washington Streets. If a person walked one block from the photographer's viewpoint and looked to the right, the city courthouse could be seen set back from Washington Street.

The LaSalle Street Tunnel was one of the tunnels that helped save many lives. It was featured in a story by Charles F.W. Mielatz in 1898, which recalled his memories of the fire as a young boy. (Courtesy Newberry Library.)

Two

Parade of Fire

What has become known as the Great Chicago Fire might be better called the Great Chicago Firestorm, which was part of the Peshtigo Paradigm and linked with both Wisconsin and Michigan by a huge triangle of horrific, intense firestorms occurring on the same night and almost the same time. (There is more information on the Peshtigo Paradigm in chapter three.)

In Chicago, the fire started sometime close to 9:00 p.m. on October 8, 1871, at 137 DeKoven Street and got out of control very quickly with 30 mile-per-hour winds. Just before midnight, it jumped the South Branch of the Chicago River and was moving in a northeasterly direction. By 1:30 a.m. on Monday, October 9, the courthouse and other buildings in the business district were in flames and were destroyed one by one with crowds of people fleeing toward the lake. During the entire day of Monday, October 9, 1871, the fire devastated all of the business district and most of the north side. It finally started to burn itself out in the early morning hours of Tuesday, October 10, by the time it reached Fullerton Avenue. Historians are still unsure if the light rain that started extinguished the fire, or if it just burned out, or both.

Within a 30-hour time frame, the once beautiful city of Chicago was transformed into ashes, with 18,000 buildings destroyed and nearly 100,000 residents left homeless. The estimated loss of life was 300 people, but many of those bodies were never recovered, and there could have been more.

Although there are no known photographs of the actual fire while it raged, there are many photographs of the aftermath to show the scope of the destruction. This chapter presents a historical record of the "parade of fire" that marched through Chicago on October 8–10, 1871.

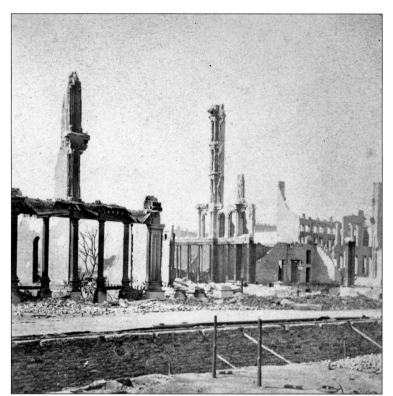

Before the fire, this intersection was home to the six-story Honoré Block, designed by Otis L. Wheelock, and the Bigelow House. The Shepard Building was directly to the south. The intersection is now home to the historic Marquette Building (1895) and Chicago's Federal Center.

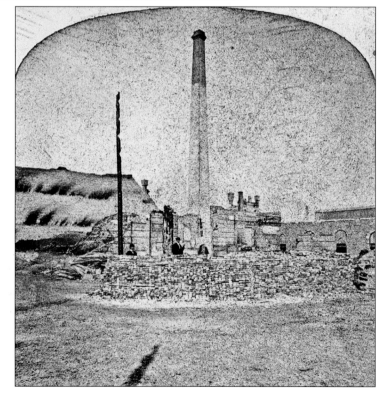

The Adams House was a hostelry, with John J. Pearce and Schuyler S. Benjamin as proprietors, and was built in 1858. It was a five-story building at the northwest corner of Michigan Avenue and Lake Street and was known as a most "proper" hotel. It could accommodate more than 300 guests.

The American Express office, also called the American Merchants' Union Express, was located at 96–98 Dearborn Street near the intersection of Lake Street. Charles Fargo was the assistant general superintendent, and O.W. Barrett was the agent.

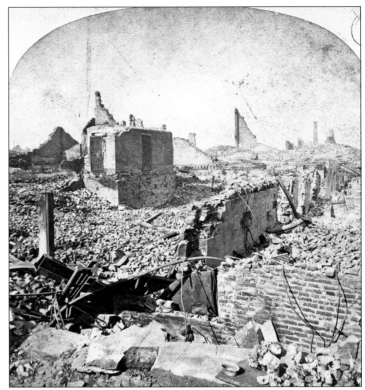

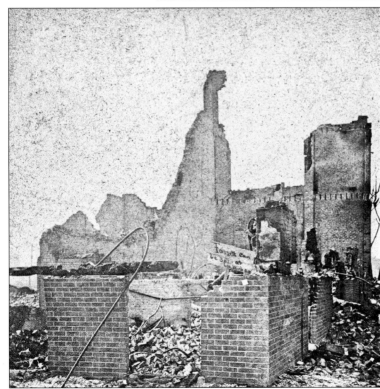

The S.M. Fassett Art Gallery was at the southwest corner of Wabash Avenue and Van Buren Street. Samuel M. Fassett had his photograph studios here, and his wife, Cordelia, displayed her oil paintings, along with work by other local artists. The gallery opened on May 9, 1870, and burned 17 months later. A handwritten sign directs people who wish to see Fassett to visit him at 662 Michigan Avenue.

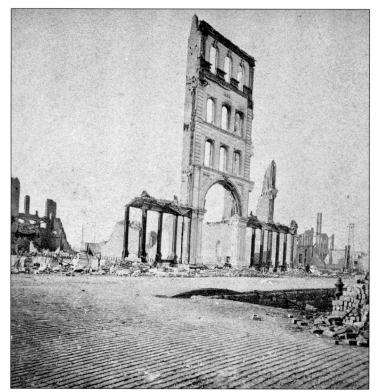

The Bigelow Hotel, also known as the Bigelow House, was at the southwest corner of South Dearborn and West Adams Streets. The hotel was designed by John K. Winchell. It had a façade made of Athens marble and was scheduled to have its grand opening on October 9, 1871—the day of the great fire.

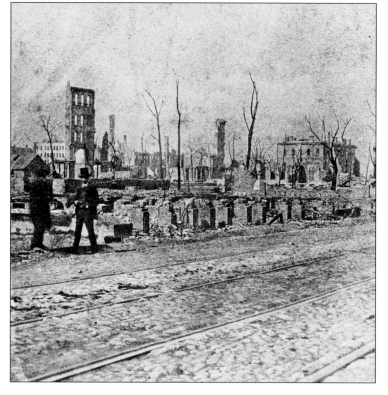

Pictured are the ruins of the Bigelow House and the post office. The property that the Bigelow House stood on was acquired by the federal government shortly after the fire for a new US Post Office and Custom House and is now part of Chicago's Federal Center.

This is a view of the ruins at the corner of State and Madison Streets. The photograph was taken from the site of the Tribune Building, which was at the southeast corner of Dearborn and Madison Streets. This was the first structure constructed specifically for the *Chicago Tribune*.

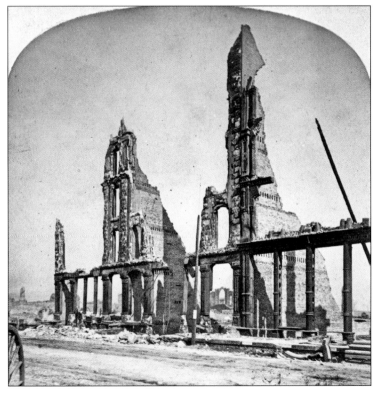

This is a close view of the ruins of the building at 111–123 State Street, which was on the east side of State Street just north of Madison Street. This five-story building was home to several businesses, including the Western News Company, S.C. Griggs & Company, and W.B. Keen & Cook. (Courtesy Library of Congress.)

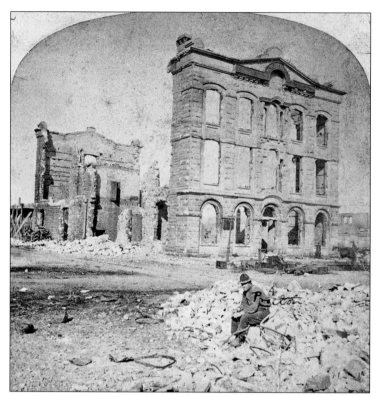

The Chicago, Burlington & Quincy Railroad offices were located at the foot of South Water Street. Trains would leave from the Central Union Depot at the foot of Lake Street. The president at the time was J.F. Joy, with A.T. Hall as secretary. The general ticket agent was S. Powell, and the freight agent was E.R. Wadsworth.

The ruins of residences can be seen near the intersection of Illinois and Cass Streets (now Wabash Avenue). The area is now part of the River North neighborhood. Nordstrom and the Hotel Palomar stand near the site today.

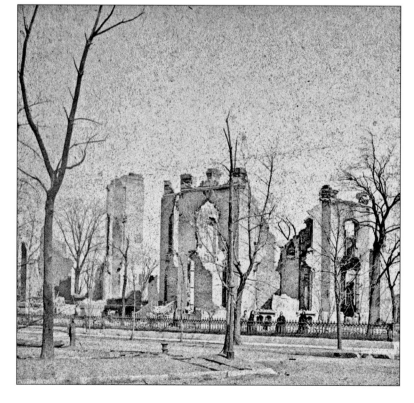

This is a view of the ruins of residences looking east from Cass Street (now Wabash Avenue). The fire had jumped the Chicago River twice and had been burning for roughly 12 hours before this part of the city began to burn.

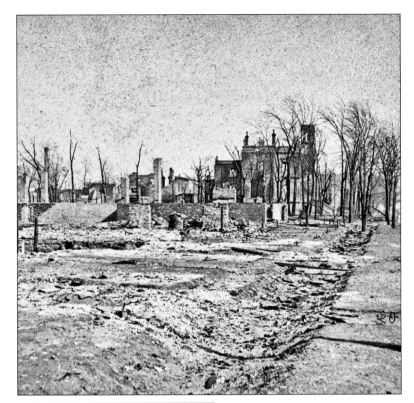

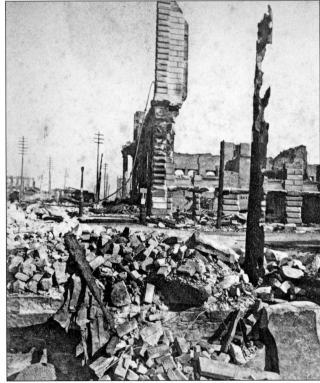

Looking east from the intersection of LaSalle and Washington Streets, the ruins of the Chamber of Commerce Building can be seen. The structure, also called the Board of Trade Building, stood on the southeast corner of LaSalle and Washington Streets and was three stories high. Edward Burling was the architect.

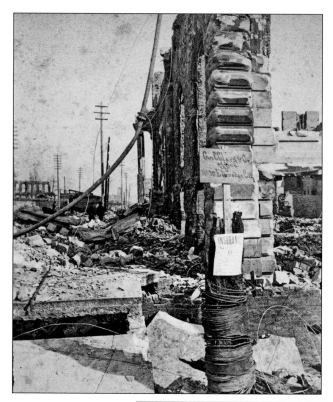

This is a close-up view of the ruins of the Chamber of Commerce Building at Washington and LaSalle Streets. The first meeting of the Board of Trade was held on March 13, 1848, although this particular building was not constructed until 1865. Note the hand-made sign for George C. Clarke & Co. (George C. Clarke and Samuel M. Nickerson), insurance agents with an office in room 15 of the building.

The First Methodist Episcopal Church Block was built in 1857 and was designed by Edward Burling. It stood on the southeast corner of Clark and Washington Streets. The building looked very much like a commercial building and served multiple uses. The first floor was rented out by the church as retail space. The second floor was used as offices, and the third and fourth floors held the sanctuary. The pastor at the time was W.H. Daniels, who had his office in room 19.

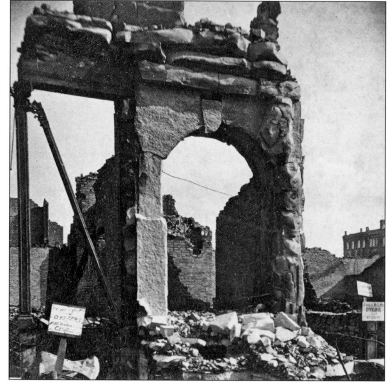

The Clark Street Bridge was near the LaSalle Street Tunnel, which saved many lives during the fire. The tunnel was completed shortly before the fire, on July 4, 1871. It is ironic that after saving so many lives in 1871, the tunnel witnessed so many deaths after the capsizing of the SS *Eastland* in 1915. The tunnels are now sealed.

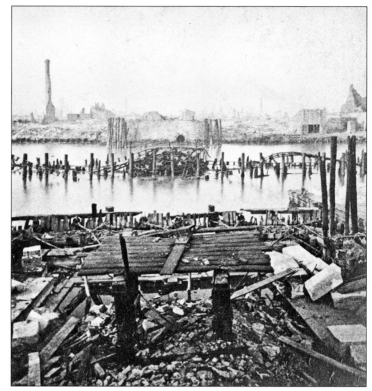

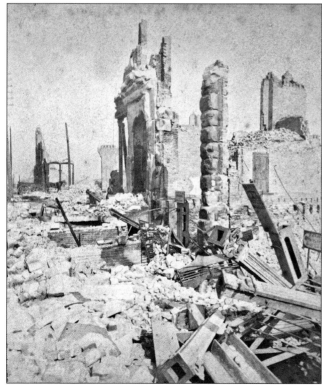

This view shows the northeast and southeast corners of Clark and Washington Streets. The closest archway is what was left of the First Methodist Episcopal Church, and the ruins in the distance are those of the Bryant Stratton Business College, which is still operating under that name in New York, Virginia, Ohio, Wisconsin, and online.

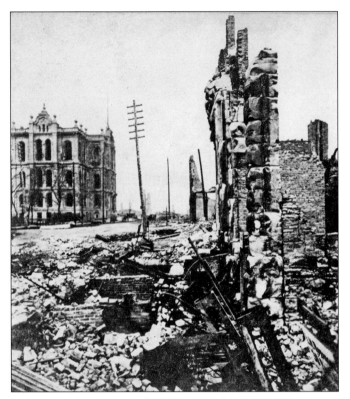

The west wing of the Chicago City Courthouse on Clark and Washington Streets can be seen at left. The First Methodist Episcopal Church is in the foreground, and the Bryant Stratton Business College is directly across Clark Street from the courthouse.

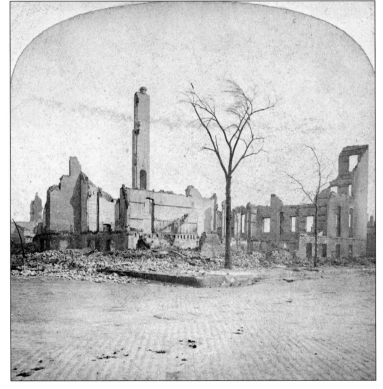

The hotel known as the Clifton House stood at the southeast corner of Madison Street and Wabash Avenue. The address was 30–32 Madison Street, and the proprietors were W.A. Jenkins and Albert A. Holmes. Thomas "Tad" Lincoln, Pres. Abraham Lincoln's youngest son, died at the Clifton House on July 15, 1871, due to dropsy of the chest less than three months before the fire.

Col. J.H. Wood's museum, which opened in 1862 as the Chicago Museum and Fine Art Gallery on the north side of Randolph Street, east of Clark Street, was Chicago's answer to P.T. Barnum's New York museum. Basically, it was the equivalent of a permanent "freak show" or side show. It stood at 111–117 Randolph Street, and one of the star attractions was the 96-foot-long skeleton of a sea serpent called a zeuglodon that was supposedly discovered by Albert Koch in Alabama in 1846.

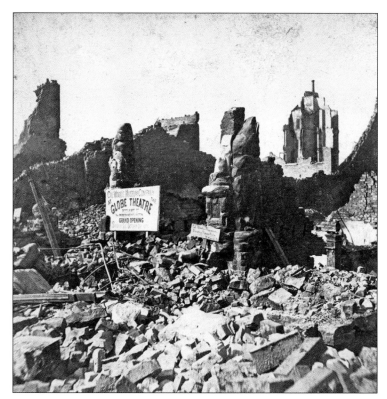

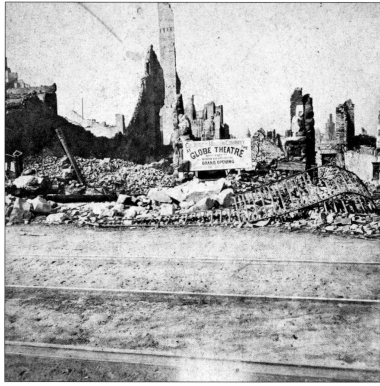

In this photograph of Colonel Wood's museum is an advertisement for the Globe Theater, which Colonel Wood added by incorporating the rear of the building known as Kingsbury Hall. Wood took over as manager from Frank E. Aiken in 1864. The object that looks like a fence in the ruins was actually one of the outside balcony railings from either the second or third floor.

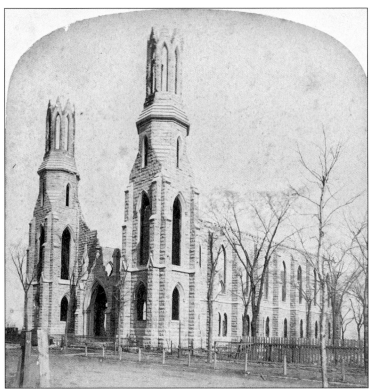

Unity Church, sometimes called Collyer's Church, was a United Brethren in Christ church located at the southeast corner of Dearborn and Whitney Streets (now Walton Street). The church was designed by Theodore V. Wadskier and was finished in 1867. The pastor's name was Robert Collyer. Reverend Collyer became famous for having services in the church the Sunday following the fire. Much of the remains of the old church are incorporated into the current church at the same location.

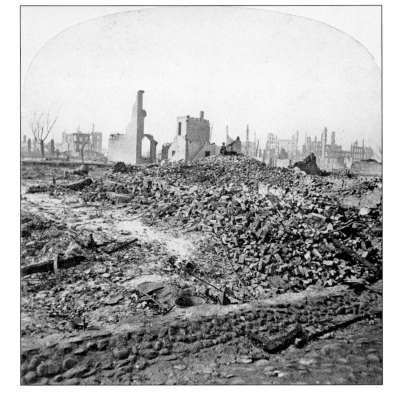

This view of the ruins from Congress Street looking southwest would today show Printer's Row and the old Dearborn Station. Congress Street at the time of the fire was only four blocks long. Today, Congress Parkway extends into the Eisenhower Expressway, which leads to the western suburbs of Chicago.

These two chaps seem to be guarding the courthouse bell within the ruins of the Chicago City Courthouse, in the same location as the current combination Chicago City Hall/ Cook County building at the corner of Washington and Clark Streets. This bell rang the alarm both the night of the great fire and for the fire the night before.

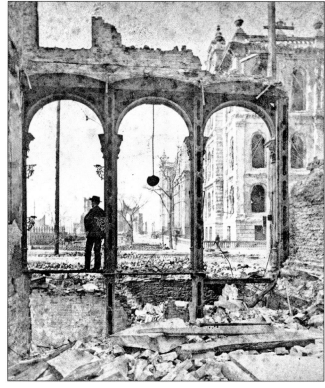

The first combined courthouse and city hall was at the corner of Clark and Washington Streets. Through the ruins of the Fifth National Bank on Clark Street, the east wing can be seen, which, in addition to the west wing, was added after the Civil War. The president of the Fifth National Bank was C.B. Sawyer. The architect of the courthouse was John M. Van Osdel.

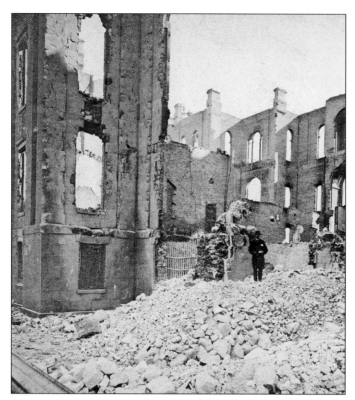

In the center of this photograph are the bars that led into the jail cells in the basement of the courthouse. Executions by hanging took place in the courthouse with a portable gallows that would be set up across the door frames of the women's courtroom and the debtors' courtroom on the second floor. A trap door large enough to hang two persons at the same time would be sprung, and the condemned would fall from the second floor into the basement, where their journey would end.

Pictured are both the east and west wings of the Chicago City Courthouse. The building stands in the same location as the current Chicago City Hall/Cook County Building. It was, and still is, bordered by Washington Street on the south, Clark Street on the east, LaSalle Street on the west, and Randolph Street on the north. The ruins of the Fifth National Bank can be seen at far right. This is where Daley Plaza is today.

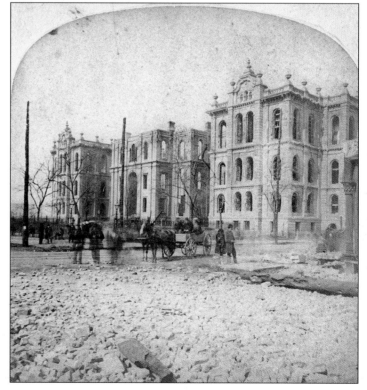

The principal courthouse building designed by John M. Van Osdel was constructed in 1853 and was two stories high. In 1858, a third story was added to the building by the same architect, and the east and west wings were added after the Civil War. The courthouse was the last place that Pres. Abraham Lincoln's remains would lie in state before the funeral's final stop in Springfield, Illinois. The courthouse was open around the clock from May 1, 1865, until late in the evening on May 2, 1865.

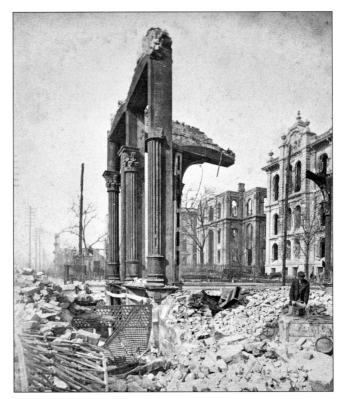

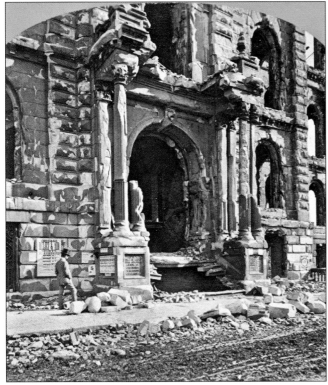

In this close-up view of the west wing of the courthouse, it is clear what an imposing structure this was, especially to those jailed in the basement. A sign for the Chicago Relief and Aid Society is posted on the left wall outside the entryway. The society was created in 1851 and designated the primary relief agency for the city after the fire by Mayor Roswell B. Mason. The society's office was at 213 Randolph Street. The president was Wirt Dexter, and its secretary was O.C. Gibbs. It provided food, shelter, clothing, and monetary relief to the citizens affected by the fire and was so successful at raising money that it had a $600,000 surplus after official relief efforts ceased. The society was also instrumental in vaccinating over 60,000 people against smallpox.

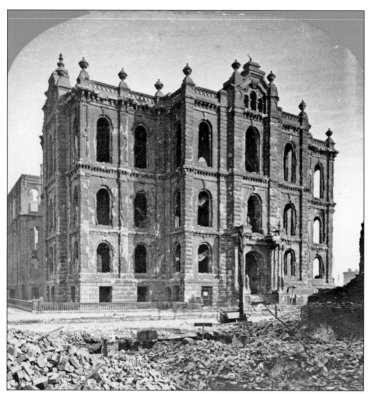

Decorative finials adorned the top of the west wing of the courthouse, seen in this view from LaSalle Street. After the fire, these finials were sought by souvenir collectors. One such collector, Seth Wadhams, brought back two of the finials to his property in Elmhurst, Illinois. One of the finials still survives in Elmhurst's Wilder Park. There is also one in front of the Matthew Laflin Memorial Building (1893), which housed the Chicago Academy of Sciences in Lincoln Park.

The devastation is evident in this wider southern view of the courthouse from Clark and Monroe Streets. A watchman on duty in the top tower was surveying the city for fires and emergencies and received the telegraph fire alarms, but after a series of delays and mistakes, the fire was raging by the time firefighters arrived at DeKoven Street, and they could not contain it. The huge bell was constantly ringing to warn people of the fire, and when the flames came about 2:30 a.m. Monday, October 9, 1871, the bell tumbled down in a loud crash. Historians now mark the moment when the courthouse bell crashed as the end of old Chicago and the start of the new.

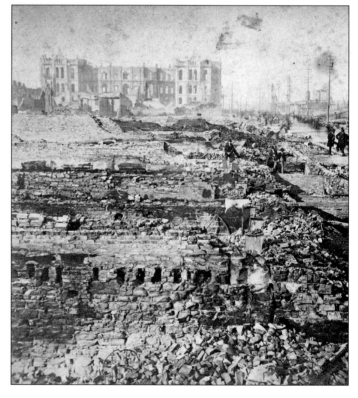

The US Post Office and Custom House was planned by Ammi B. Young of the Treasury Department, and the superintendent of construction was Col. John H. Eaton of Chicago. The building was three stories high with a basement and served multiple purposes. The basement and main floor were dedicated to the post office. The second floor contained the offices of the collector of customs, the public depositary, the collector of internal revenue, steamboat inspector, US marshal, US commissioner, and the clerks of the post office. The third floor housed the federal courts, clerks, district attorney, and rooms for jurors. The building was finished in 1860 at a cost of $243,000.

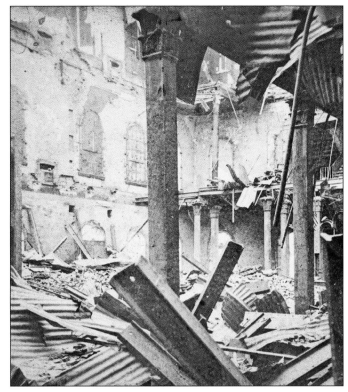

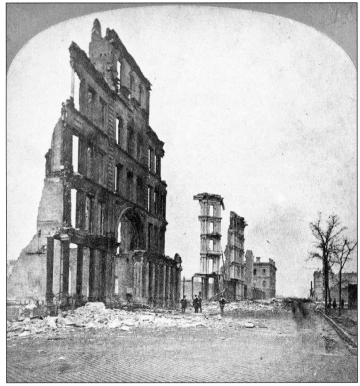

In this north view of Dearborn Street from Jackson Street, the ruins of the Bigelow House, Honoré Block, Reynold's Block, and the US Post Office and Custom House can be seen on the west side of the street. Today, the main landmarks in this spot are the Federal Center and the Marquette Building.

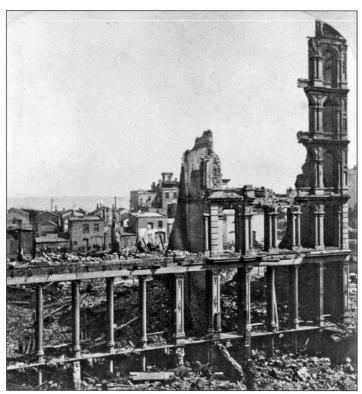

Drake's Block, also known as the Drake and Farwell Block, was originally built in 1870 and was seven stories high, but burnt down. The second Drake Building, whose ruins are pictured here, was only five stories high and was located on the southeast corner of Washington and Wabash Streets. It was once the home of John Burroughs Drake, whose sons John B. Drake and Tracy C. Drake were the developers and proprietors of the Blackstone and Drake Hotels in Chicago. John Burroughs Drake was also part owner of the Tremont House, which burned in 1871.

Young Marshall Field and Levi Leiter had formed a partnership and bought out Potter Palmer's dry goods store in 1863. In 1868, they moved into this huge building, known as Palmer's Marble Palace (which later would become the site of the current Macy's), on North State Street. Well before the flames arrived, a quick-thinking young executive, Harlow Higinbotham (later president of the 1893 World's Columbian Exposition), and others removed the most expensive merchandise, storing it under guard at the lakeshore and at Leiter's home. Despite great efforts to save the building, and even though it was mostly made of limestone, it was entirely destroyed and reduced to rubble—and $2.5 million worth of stock and furnishings became ashes.

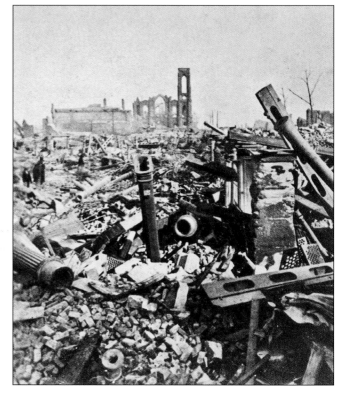

The Fifth National Bank was more or less directly across Clark Street from the city courthouse in the area where Daley Plaza stands today, at 55 West Washington Street. In an October 28, 1871, edition of the *Chicago Tribune*, the bank promised its customers that it would rebuild immediately at the northwest corner of Madison and Fifth Streets (now Wells Street) and would occupy that building by December 1, 1871.

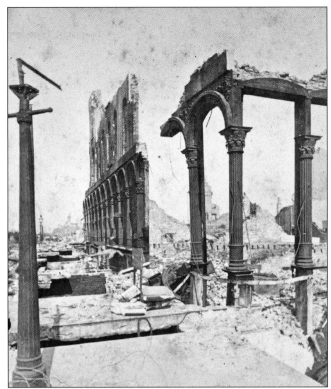

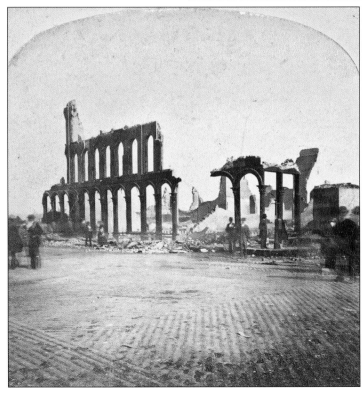

C.B. Sawyer was the president of Fifth National Bank during the great fire, and Nelson Ludington was the vice president. Ludington went on to become president of the bank after the fire. His brother Harrison Ludington was a three-term mayor of Milwaukee, Wisconsin, and also served as the governor of Wisconsin from 1876 to 1878. Ludington's grandfather, Henry Ludington, served in the Dutchess County, New York, militia during the American Revolution and was an aide to Gen. George Washington. Nelson Ludington died in 1883 and is buried at Chicago's Graceland Cemetery.

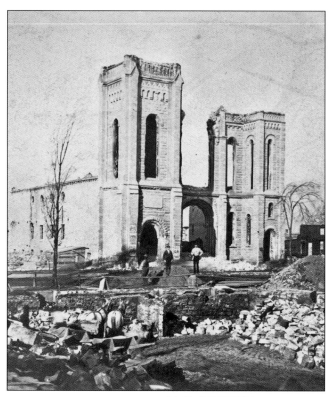

A note in the surviving First Presbyterian Church records states, "On Sunday, October 8, a collection was taken in the church for the benefit of the sufferers from a severe conflagration which had visited the West Side on Saturday night. It was Communion Sunday; none realized that it was the last one in the old church, around which so many precious memories clustered. That night a fire broke out in the West Division, crossed to the South Side, and then to the North, destroying a large portion of the city. Early on Monday morning, our beautiful church home, as well as its beautiful chapel and the Railroad Mission chapel, was destroyed. Nothing was saved but the records of the church, the Communion service and the Sexton library."

This northwest view from the Michigan Avenue Hotel shows the ruins of the First Presbyterian Church. It was established in Chicago in 1833. The building pictured was dedicated on March 27, 1864, and stood at Wabash Avenue between Congress and Van Buren Streets. The Michigan Avenue Hotel opened in 1870 and was located at the southwest corner of Michigan Avenue and Congress Street. It was purchased by John B. Drake as the great fire burned across the street. The owner agreed to sell, thinking the hotel was doomed. Drake's bet paid off, and he renamed the building the New Tremont House after the hotel he had lost in the fire.

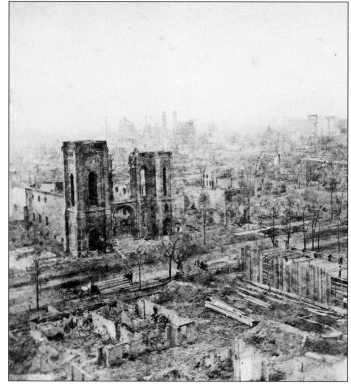

In this photograph taken from the Michigan Avenue Hotel looking north, the remains of Terrace Row can be seen in the foreground. The Michigan Avenue Hotel, which miraculously survived the fire, sat on land that the Congress Hotel occupies today.

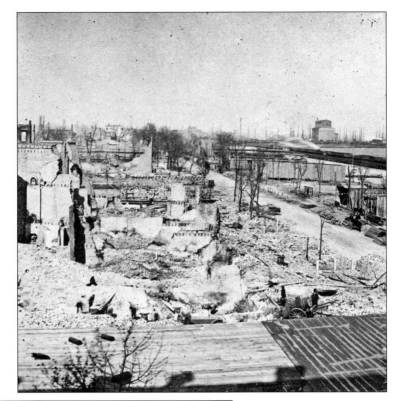

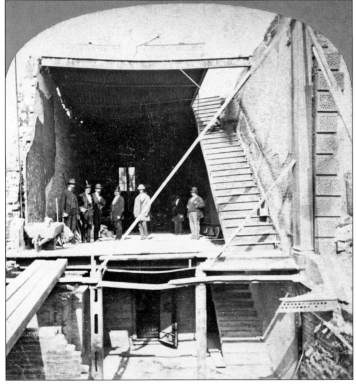

Thomas Barbour Bryan's safe depository was located at 143 Randolph Street, which would put it at the northeast corner of Randolph and LaSalle Streets. The name of the business was the Fidelity Safe Depository. Bryan was instrumental in arguing before Congress as to why Chicago should host the 1893 World's Columbian Exposition. His home was at Cottage Hill, which changed its name to Elmhurst shortly before the great fire.

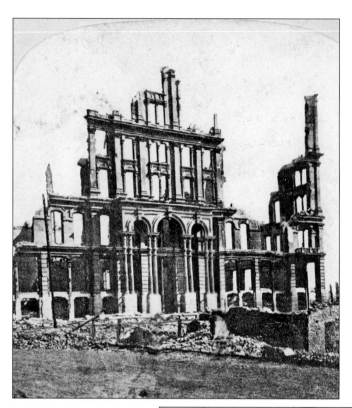

The Grand Pacific Hotel was being constructed at the time of the great fire. It stood at the northeast corner of LaSalle and Jackson Streets. It was six stories high and was designed by William W. Boyington, whose work can still be seen in the Chicago Water Tower, the old Joliet Prison, and the front entrance to Chicago's famous Rosehill Cemetery. Boyington was also famous for being the architect of the Illinois State Building at the 1983 World's Columbian Exposition. The replacement building was constructed on the same foundation as the original. The Continental Illinois Bank Building occupies the space today.

This view of the Honoré Block looks through the ruins from the inside of the building onto Dearborn Street. The building was situated on the southwest corner of Dearborn and Adams Streets. It was designed by architect Otis L. Wheelock, was six stories high, and was equipped with an Otis patent steam passenger elevator.

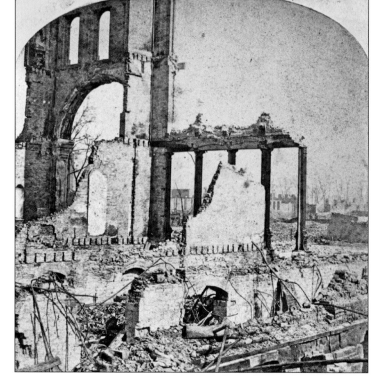

Henry Hamilton Honoré was the money behind both the first and second Honoré Blocks. The first was finished shortly before the great fire, and the second adjoined it and was not finished until after the fire. H.H. Honoré was the father of Bertha Honoré, who married famed Chicago businessman Potter Palmer. Palmer had promised her a hotel as a wedding present, and three weeks before the fire, opened the Palmer House. Bertha went on to become arguably Chicago's first lady of society and was the president of the Board of Lady Managers of the 1893 World's Columbian Exposition.

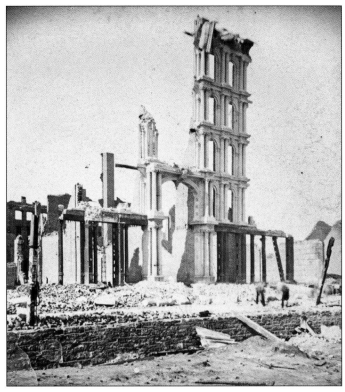

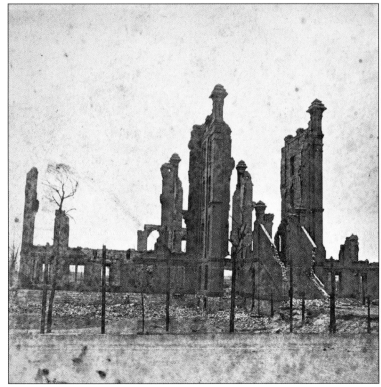

The House of the Good Shepherd was a Roman Catholic convent located on the east side of Sedgewick Street, near Division Street. After the fire, the church rebuilt the convent across from the new St. Joseph Church. It was on Sedgewick Street, bordered by Hill, Elm, and Market Streets (now Orleans Street). The area is now part of Seward Park.

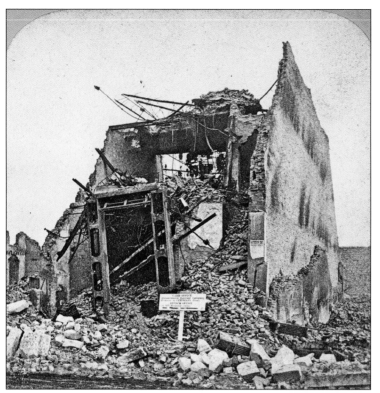

The Land Office of the Illinois Central Railroad was located on the east side of Michigan Avenue, between Lake and South Water Streets. The Land Office was tasked with reporting to the State of Illinois land that was owned by the railroad and sold to private parties so that the proper taxes could be assigned. The Illinois Central Railroad roundhouse at Ann and Washington Streets was used by the city government as a location to distribute food and to swear in those volunteering to be special policemen to keep peace after the fire.

The Merchants Insurance Building was on the northwest corner of Washington and LaSalle Streets. The president of the company at the time of the fire was W.E. Dogget, and George Armour was vice president. Gen. Phillip Sheridan had his offices in the building, and his personal papers were saved from the fire by his confidential clerk, Daniel O. Drennan.

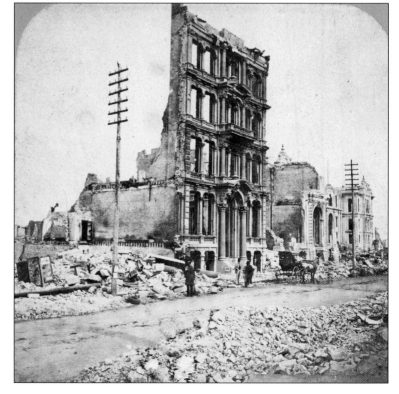

This view of the southwest corner of Lake and Clark Streets shows the ruins of the Exchange Bank Building. At the time of the fire, it was home to the Hibernian Banking Association Savings Bank. J.V. Clarke was the president, and Hamilton B. Dox was the cashier.

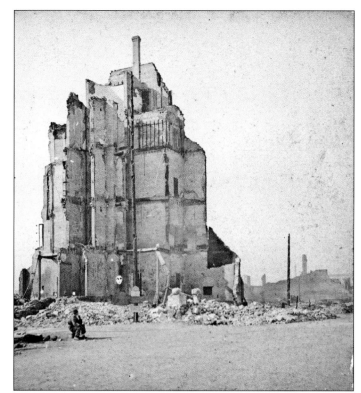

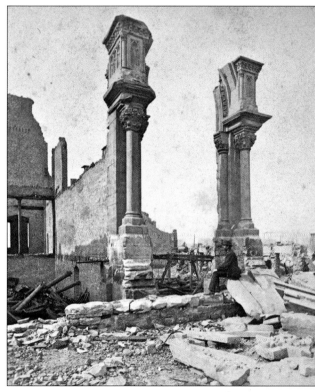

The Lakeside Publishing House was on the southwest corner of Dearborn and Washington Streets. Richard Robert Donnelley started his printing operations as the Lakeside Publishing and Printing Company and adopted the trade name of Lakeside Press, which would be used in the company's branding for more than 100 years. The great fire wiped out Donnelley's business, and his insurance company could not make good on the loss. However, he managed to get funding from a New York bank on the reputation of his name. The company rebuilt at the corner of Clark and Adams Streets, and in 1874, it started the Lakeside Chicago City Directory.

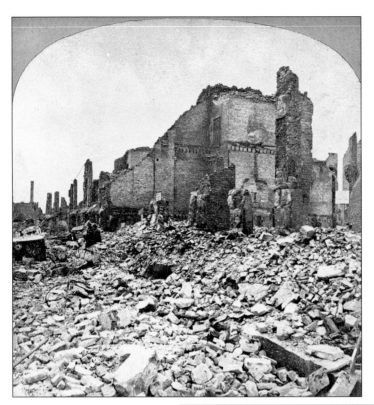

The intersection of LaSalle and Washington Streets was, and still is, a major intersection for commerce in the city. At the time of the fire, the area included the Aetna Building, Chamber of Commerce Building, Merchants Insurance Building, Phoenix Building, the Mercantile Building, and the city courthouse. Today, the City Hall/Cook County Building, constructed in 1911, occupies the original site of the courthouse.

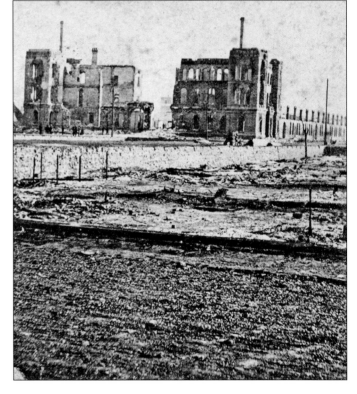

The Lakeshore & Michigan Southern Railroad depot was located at the southwest corner of LaSalle and Van Buren Streets. It was completed in 1866 and designed by architect William W. Boyington. The building measured 542 feet by 160 feet. The roof was 60 feet high. The building had a restaurant as well as a ladies' dining room. There were three tracks for arriving trains and two for departing trains.

The Merchants Insurance Building was at the northwest corner of Washington and LaSalle Streets. In addition to Daniel O. Dennan saving Gen. Phillip Sheridan's personal memoirs and important documents, he went back in a second time to save items belonging to Gen. George Custer as the building burned around him. Dennan dragged the trunk containing the documents back to his house, only to watch it burn. He escaped over the river via a bridge that General Sheridan was working to keep open.

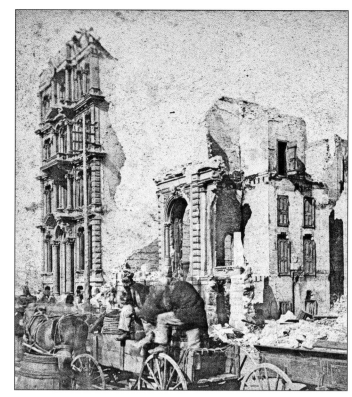

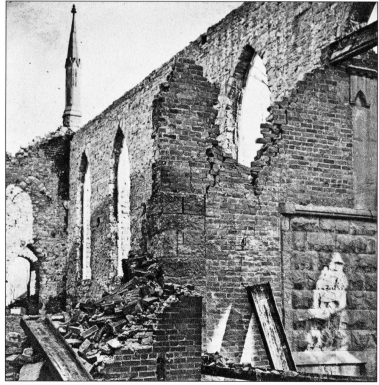

The interior of the New England Church shows the sun shining through one of the windows, which at one time held stained glass. It almost gives the impression or feeling of hope that Chicagoans were looking for after the devastating fire. Amazingly, puritan relics from Scrooby Manor and a piece of Plymouth Rock that were inserted into the archway of the building above the door survived the fire.

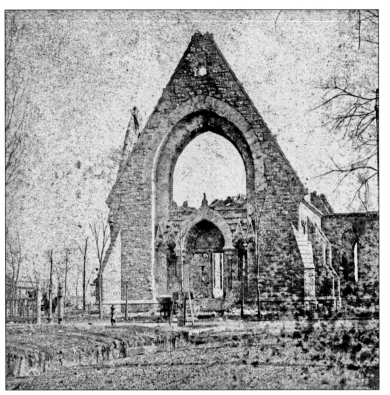

The New England Church was a Congregationalist church that was just south of Unity Church at Dearborn and Whitney Streets (now Walton Street). It was within one block of the Mahlon D. Ogden house. Mahlon was the brother of William Odgen, who was Chicago's first mayor. The Congregationalists believed in the autonomy of individual churches that were "ruled" by the congregation and not a church hierarchy.

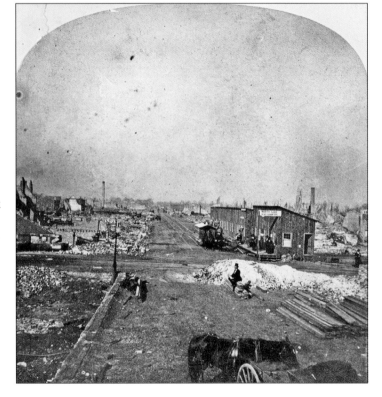

This view of North Clark Street shows just how complete the devastation was. Most buildings, with the exception of only a few of the larger and more "fireproof" structures, were reduced to nothing more than rubble. Some of the locations in these images are difficult to discern from photographs alone.

Directly across the street from this line of buildings on LaSalle Street was the Nixon Block, the first "fireproof" building constructed in Chicago. The Nixon Block's builder was W.K. Nixon, who came from Cincinnati nine years prior to the great fire. The building had joists of wrought iron and floors of marble. The roof had a solid inch of plaster of Paris. The architect was Otto H. Matz, and following the fire, the building had a plaque installed that read, "This fireproof building is the only one in the city that successfully stood the test of the Great Fire of October 9, 1871."

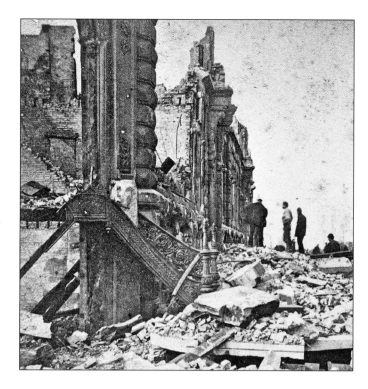

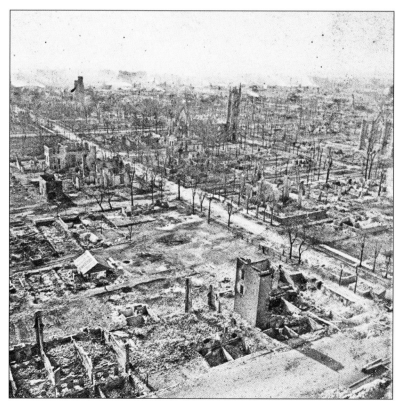

This north view of the ruins gives an idea of what the devastation was like. Most people did not believe that the fire would jump the Chicago River twice. Those north of the river thought that they were safe, but the fire spread so rapidly that people had to run to Lake Michigan to stay ahead of the flames. Note the ruins that are still smoldering in the distance.

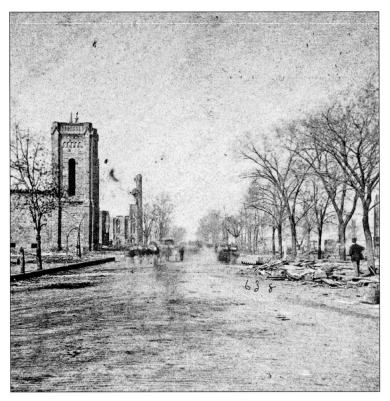

This view of Wabash Avenue would have been taken at Harrison Street looking north. The Wabash Methodist Church is on the left. C.H. Fowler was the pastor. The church held public services on Sunday morning and Sunday evening, prayer meetings on Wednesday evenings, and Sunday school at 2:00 p.m.

This photograph was taken on the west side of Dearborn Street looking south. The church steeple in the background is that of Unity Church on what is now Walton Street. Mahlon Odgen's house was just out of view to the right, or east. The house was saved through the use of water-soaked rugs hung on the outside and roof of the building to prevent sparks from igniting it. Odgen's house was one of the very few structures that survived the fire. The renowned Newberry Library occupies the space today.

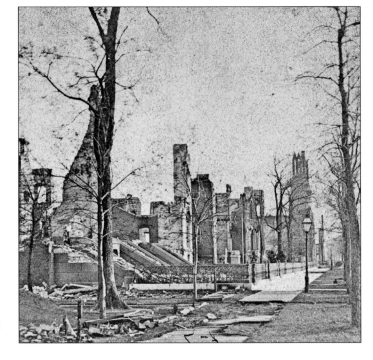

It would be at least noon on October 9 before the fire reached the north side of the city. The ruins of this mansion on Ontario Street give an idea of the wealth of the residents on the north side of the city as opposed to the wooden shack owned by the O'Leary family on DeKoven Street in the southern district. The O'Leary family was stigmatized for a long time after a rumor was spread about their cow kicking over a lantern and starting the blaze.

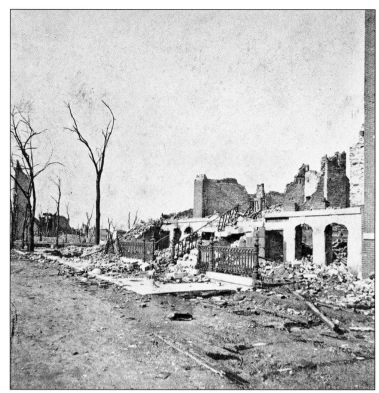

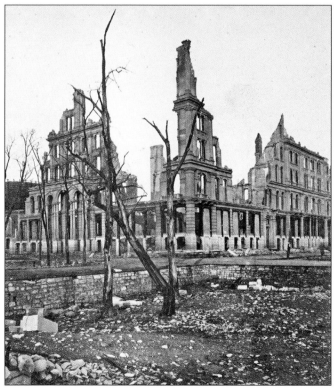

The Grand Pacific Hotel was in the process of being built when the fire occurred. It was a six-story structure designed by W.W. Boyington. When it was rebuilt on the same foundation, the new Grand Pacific Hotel was again six stories and designed by W.W. Boyington. The hotel was the site of the 1883 Time Convention, which was held by the nation's railroads to develop a more uniform system of time in the country. On October 11, 1883, the railroads adopted the Standard Time system that is in use today. The time zones were utilized by the general population almost immediately after it was inaugurated on November 18, 1883, but it was not adopted officially by the federal government until March 19, 1918.

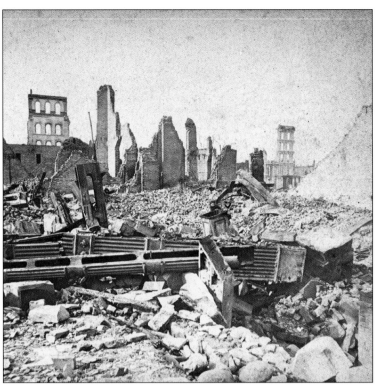

It is hard to believe that the pile of rubble pictured here was once the luxurious Palmer House. The hotel was at the southeast corner of State and Monroe Streets and had just opened the March prior to the fire. The building was seven stories high, and the architect, John M. Van Osdel, who was thinking on his feet, took the only copy of the blueprints and buried them in a clay pit in the basement of the hotel. The fire baked the clay, but the documents were protected.

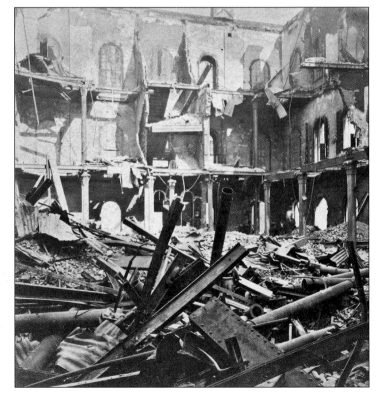

This view of the interior of the US Post Office and Custom House does not give any indication of the treasure that was once stored here. It was the second-busiest post office in the country next to New York. In addition to burned mail, $1.3 million in currency was destroyed. There was also a gold depository, but that simply melted and was recovered shortly after the fire.

This view of the US Post Office and Custom House is quite deceiving because it looks as though the building was unscathed. The building, however, was completely hollowed out by the intense heat of the fire. Amazingly, a cat, who was the unofficial mascot of the post office, did not leave the building during the fire but was found alive in a bucket partially filled with water behind a partition. The cat was known as the only living creature that survived both Sunday and Monday night in the burned district.

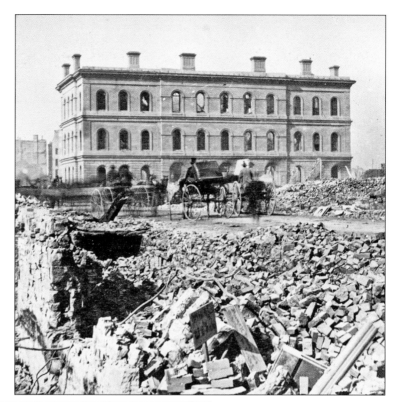

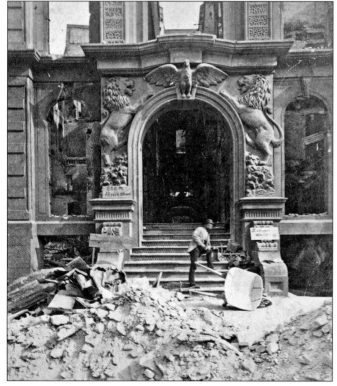

The Republic Life Insurance Building was on LaSalle Street, between Madison and Monroe Streets. It was built in 1870 and designed by architect George H. Edbrooke. The structure was used by the custom house and US courts for several years after the fire until a new government building was completed.

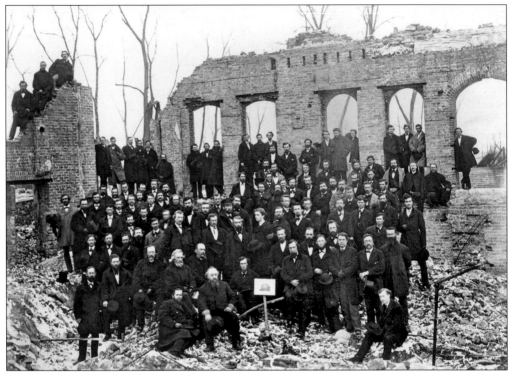

Rush Medical College was on North Dearborn Street at Indiana Avenue. It is one of the oldest medical colleges in Illinois and was chartered two days before the City of Chicago itself in 1837. Its founder, Dr. Daniel Brainard, named the school after Dr. Benjamin Rush, who was the only physician with medical school training who signed the Declaration of Independence. After the fire in 1875, the college moved to Harrison and Wood Streets. (Courtesy Rush Archives.)

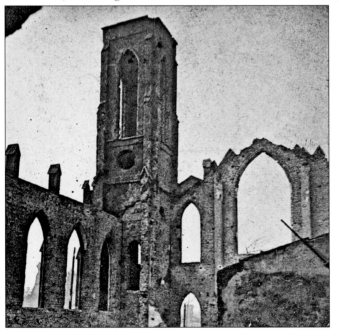

The Second Presbyterian Church was located at the northeast corner of Wabash Avenue and Washington Street. The building was designed by noted eastern architect James Renwick Jr. It was used as a house of worship from 1851 until just two weeks before the fire. Plans were already in the works to move the congregation south. James Renwick Jr. was again commissioned to design the new church, which was finished in 1874 and survives today at 1936 South Michigan Avenue.

The Sherman House was originally built by F.C. Sherman, who later became mayor of Chicago. It was only three stories high when it was built in 1837 and called the City Hotel. Sherman later added two floors and renamed it the Sherman House. That building was torn down in 1861, and a new, six-story Sherman House designed by W.W. Boyington was constructed on the same northwest corner of Clark and Randolph Streets until it was destroyed by the great fire.

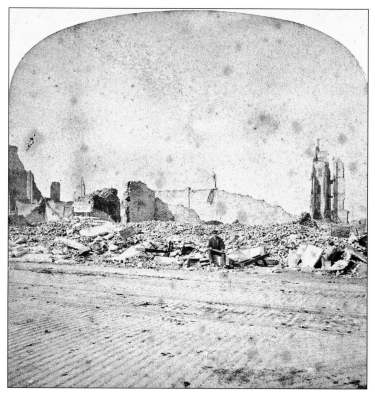

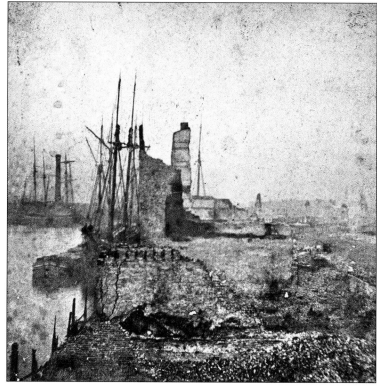

Before the great fire, commercial business was concentrated along South Water Street and in the blocks just south of the Chicago River. Bridges that spanned the river would turn to allow ships to pass, causing congestion of wagons and pedestrians. After the fire, offices moved farther south, and this area became the central produce section of the city.

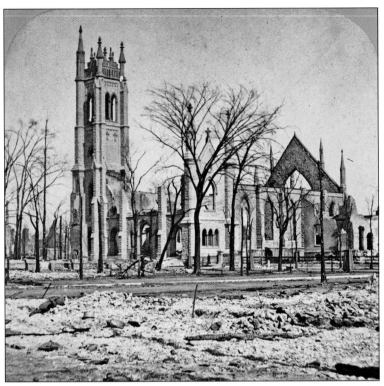

The Episcopal denomination lost St. James Church, which was at the corner of Cass (now Wabash) Avenue. It was known as one of the most elegant churches in the city at the time. The loss was about $250,000; however, there was a moderate insurance policy that was paid out. The Rev. J.H. Rylance was the rector, and the Rev. C.B. Kelly was assistant rector. The church had Sunday services at 10:30 a.m. and 4:00 p.m., with Sunday school at 9:00 a.m.

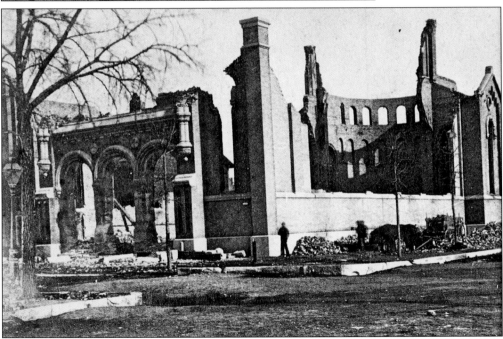

St. Joseph Catholic Church was located at the intersection of Chicago and Wabash Avenues. The pastor was Rev. Leander Schnerr. The loss of the building was worth about $100,000, and the church rebuilt at the northeast corner of Market (now Orleans) and Hill Streets, where it is still located today. The Catholic Church lost $1.161 million in real estate during the fire.

The Universalist Church lost only one church, St. Paul's. It was located on Wabash Avenue at the corner of Van Buren Street. The Rev. W.H. Ryder was the pastor. The church had services on Sunday at 10:30 a.m. and at 7:30p.m., with Sunday school at noon. The cost of the loss was $75,000. George M. Pullman was part of the rebuilding committee. After the fire, the congregation rebuilt at Michigan Avenue, between Sixteenth and Eighteenth Streets, and became known as the First Universalist Church.

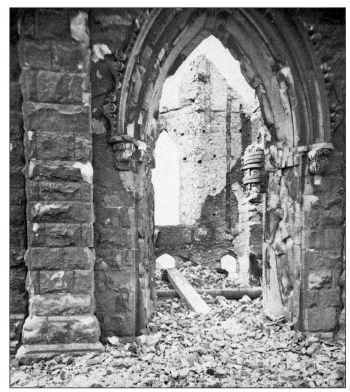

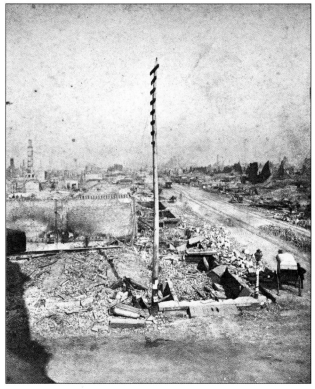

This view of North State Street from Washington Street was taken from the remains of the First National Bank Building, which stood at the southwest corner of State and Washington Streets. The building, which was finished in 1868, was originally four stories tall and was designed by Edward Burling. The fire partially destroyed the building, but its safes kept all the notes, security, and papers secure. The building was restored in 1872, with a fifth story added. The total cost of the structure was $295,000, with $75,000 for fire restoration. The president of the First National Bank was Lyman J. Gage, who went on to be the president of the board of directors of the 1893 World's Columbian Exposition in Chicago.

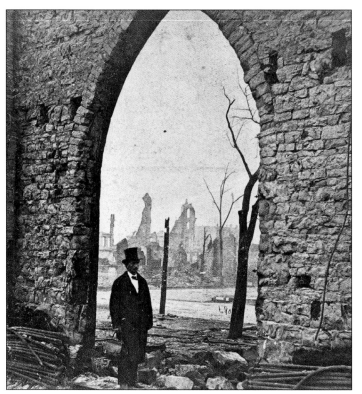

The ruins of the custom house and Chicago Tribune Building are visible through the ruins of the Second Presbyterian Church. The church was nicknamed "The Spotted Church" because of the black tar deposits in its limestone blocks. Two weeks before the great fire, the congregation had already moved south and combined with the Olivet Church while their new church was being built. Two altar chairs from the old church survived the fire because they had been sent out for repairs. They are currently displayed in the new Second Presbyterian Church, finished in 1874 at 1936 South Michigan Avenue.

The first issue of the *Chicago Tribune* was printed on June 10, 1847. Its first building dedicated to the newspaper business was constructed in 1869 and stood on the southeast corner of Dearborn and Madison Streets. This was actually the *Tribune*'s fifth location but its first permanent one, which unfortunately only lasted two years.

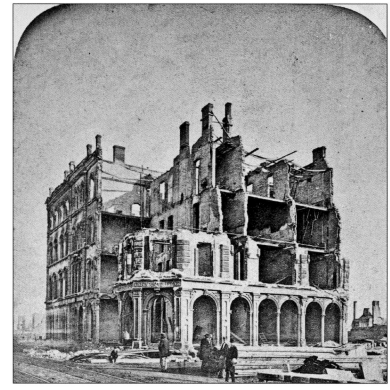

Chicago's Union Depot was built in 1858 and stood at the foot of Lake Street before the fire. It was the first predecessor of today's Union Station. The second Union Depot, or Union Station, was built in 1880 by the Pennsylvania Railroad's Pittsburgh, Fort Wayne & Chicago Railway and used by the Chicago, Milwaukee & St. Paul Railroad (later Milwaukee Road); Chicago & Alton Railroad (predecessor to the Gulf, Mobile & Ohio Railroad); and the Chicago, Burlington & Quincy Railroad (Burlington). The station was at Canal and Adams Streets. The current Chicago Union Station was finished in 1925.

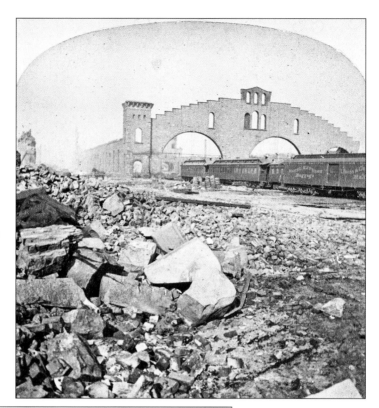

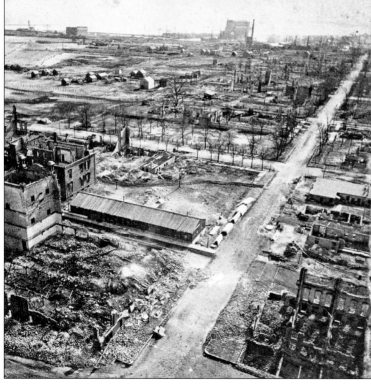

This view of the ruins of Chicago looking east from the Chicago Water Tower shows how the fire continued north and east until it stopped on the shores of Lake Michigan. This area is now the most famous shopping area in the city— the Magnificent Mile.

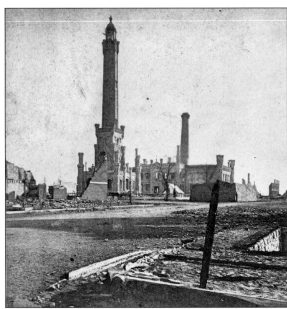

Pictured is the iconic Chicago Water Tower that survived the great fire. The tower, designed by W.W. Boyington, was built from Joliet limestone. It is 154 feet tall and was built to house a 138-foot standpipe to hold water. It is the oldest surviving public structure and the second-oldest water tower in the United States. It has become a symbol of Chicago's tenacity following the fire.

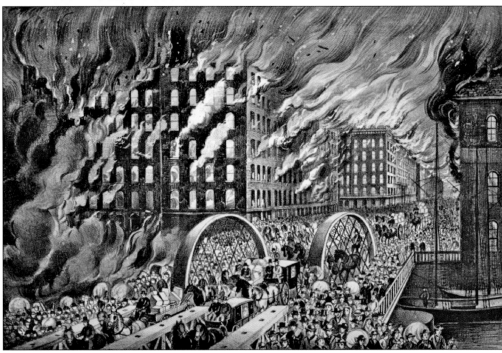

Since people did not know how far the fire reached into the western suburbs, the best place of relief was Lake Michigan, but the bridges became packed and later burned as well. The two under-river tunnels provided help, but they also became crowded and filled with smoke and heat. Some tried to jump in the river and swim across, but that proved fatal, as survivor Gertrude Anne Robison, who was 13 at the time, recalled: "Some threw themselves into the river to get across, but they were either drowned or were scalded to death because the heat was so intense by this time that the water was fairly boiling." (Courtesy Library of Congress, Prints and Photographs Division, LC-USZC4-3936.)

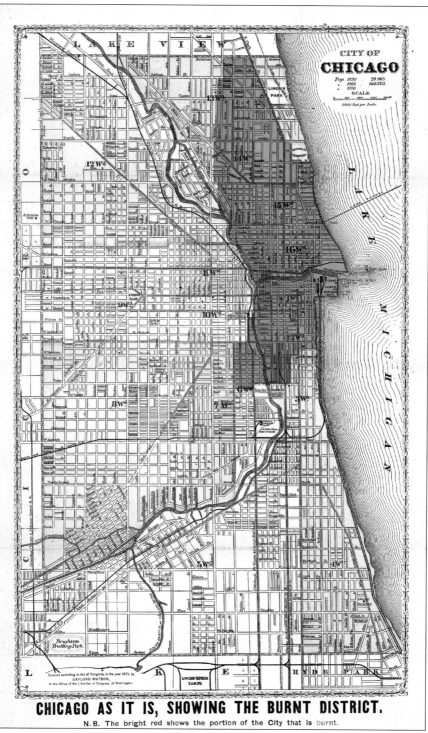

CHICAGO AS IT IS, SHOWING THE BURNT DISTRICT.

N. B. The bright red shows the portion of the City that is burnt.

This map shows the scope of the fire, starting in the O'Leary barn and jumping the South Branch and Main Branch of the Chicago River, and then devastating the downtown area and wealthy north side all the way up to Fullerton Street. (Courtesy Newberry Library.)

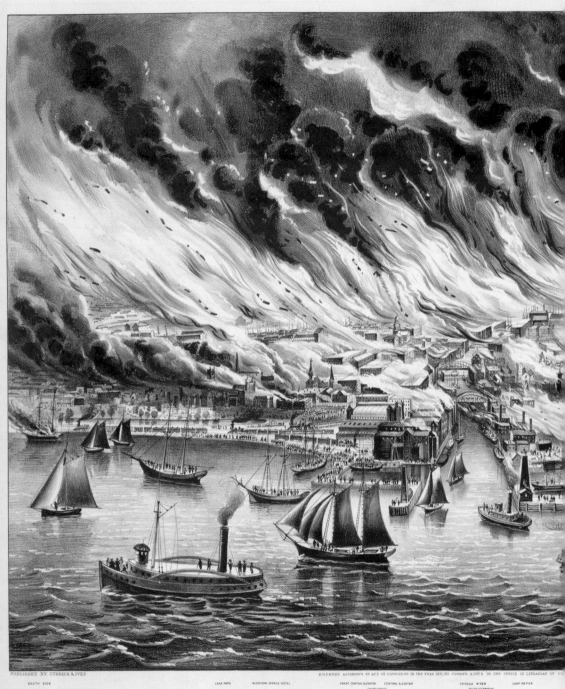

PUBLISHED BY CURRIER & IVES ENTERED ACCORDING TO ACT OF CONGRESS IN THE YEAR 1871, BY CURRIER & IVES, IN THE OFFICE OF LIBRARIAN OF CO

SOUTH SIDE LAKE PARK MICHIGAN AVENUE HOTEL GREAT CENTRAL ELEVATOR CENTRAL ELEVATOR CHICAGO RIVER LIGHT HS PIER
 COURT HOUSE RUSH ST BRIDGE

THE GREAT FIRE AT CHICAG

The Fire commenced on Sunday evening Oct. 8th and continued until Tuesday Oct 10th consuming the Business portion of

and extending over an area of Five square Miles. About 500 lives were lost, and property valued at

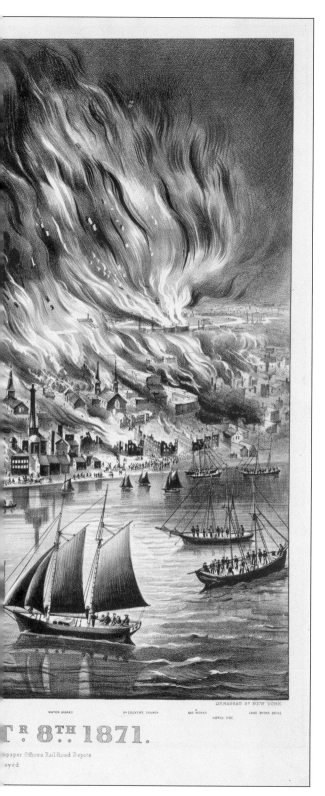

WATER WORKS D? COLYER'S CHURCH GAS WORKS LAKE SHORE DRIVE

NORTH SIDE

128 NASSAU ST NEW YORK

R 8TH 1871.

apaper Offices, Rail-Road Depots
oyed

This lithograph shows Chicago burning on October 9, 1871, but has two errors. The first is the direction of the fire, fueled by at least 30 mile-per-hour winds. It went towards the north and east, but this has it blowing south. The second is that the many sailboats and schooners seen near the shore would have been gone or racing out into the lake, as the fire extended out at least two miles into Lake Michigan. (Courtesy Library of Congress, Prints and Photographs Division, LC-DIG-pga-00762.)

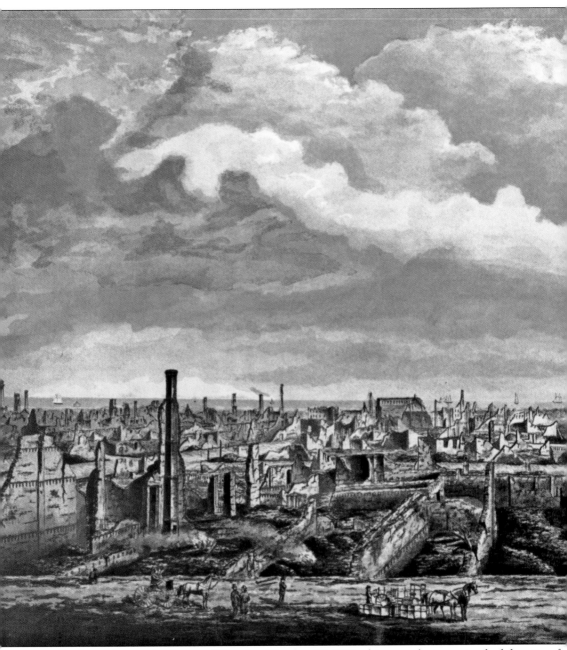

By the early morning hours of Tuesday, October 10, 1871, this was what remained of the city of Chicago. Practically every building in an area of three and one-third square miles was destroyed. Property valued at $200 million was turned into rubble, nearly 100,000 people were left homeless,

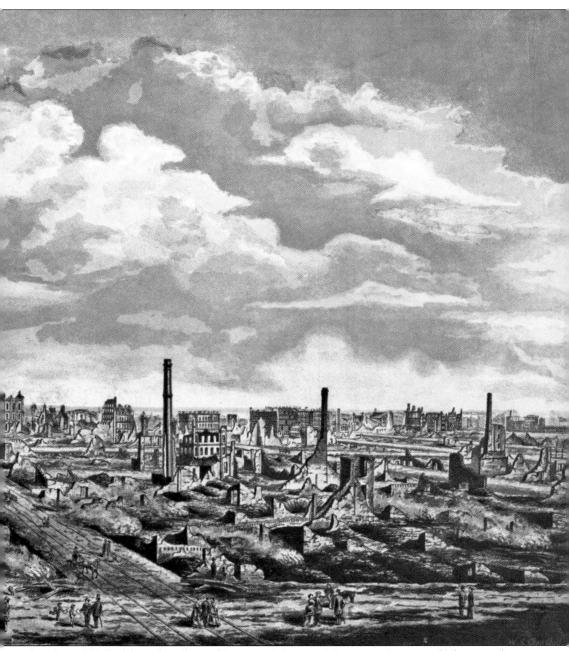
and at least 300 had lost their lives. (Courtesy Library of Congress, Prints and Photographs, LC-DIG-pga-02062.)

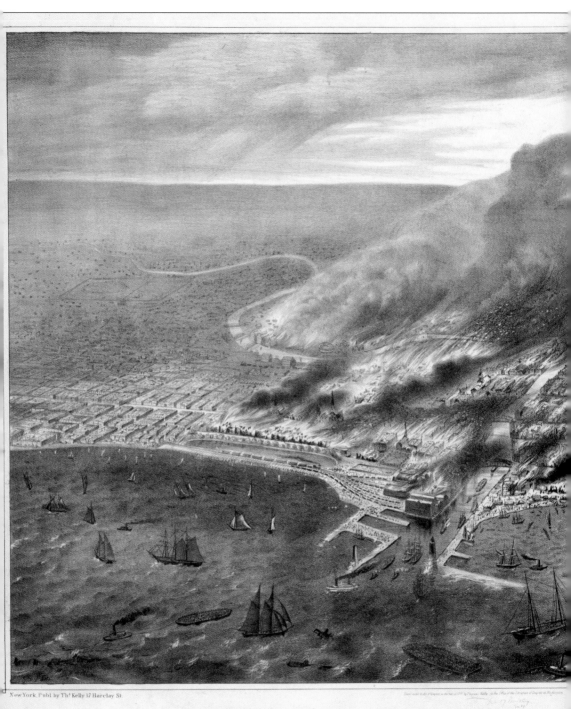

New York, Publ by Thᵒ Kelly 17 Barclay St.

DESTRUCTION OF CHICAGO BY F

This great Fire is the largest that has ever occured in ancient or modern times, beginning Oct. 8 and lasting until the 11ᵗʰ. Destroying all the Business portion of the
& Newspaper Offices, Opera House, Post Office, Board of Trade Buildings, and all the large and costly Churches, over 100,000 People were driven from there Hom
Loss is variously estimated from $ 200000,000, to $ 300,000,000, in Property and also a g

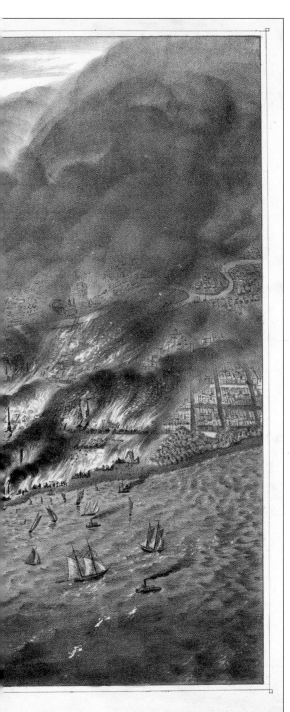

T. 1871.

...es, Rail Road Depots, Custom House, Banks, Insurance
the Lake, Parks &c. outside of the City.

Many of the survivors were amazed at how fast the fire was moving and that it seemed "the air itself was on fire." Aurelia King said, "The flames ran in our direction coming faster than a man could run." The fire destroyed approximately 100 homes per minute and swept over nearly 125 acres per hour. (Courtesy Library of Congress, Prints and Photographs Division, LC-DIG-pga-01750.)

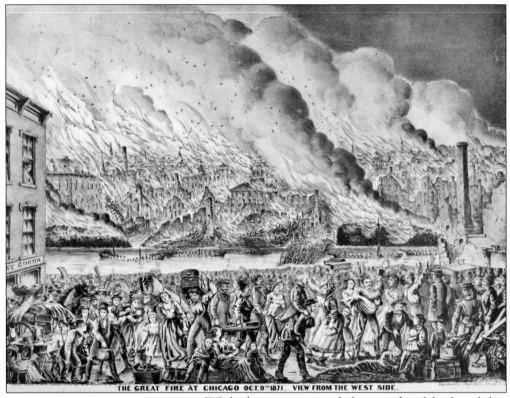

THE GREAT FIRE AT CHICAGO OCT.9TH1871. VIEW FROM THE WEST SIDE.

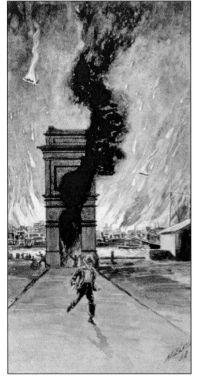

While there are no actual photographs of the fire while burning, this drawing depicts the chaos of the event. People are seen carrying possessions, and some have stolen goods. If this drawing shows Monday, October 9, 1871, in the midst of the fire, no one would be sitting or lying down, but rather running toward the lake and dodging fire brands. (Courtesy Library of Congress, Prints and Photographs Division, LC-DIG-pga-06789.)

In 1898, Charles F.W. Mielatz published a story entitled "A Boys Recollection of the Great Chicago Fire." Among other horrific scenes, he paints a picture of how he escaped the flames through the LaSalle Street Tunnel. He spoke of embers falling through the ventilation shafts. This is an illustration from that story. (Courtesy Library of Congress, Prints and Photographs Division, CAI-Mielatz, No. 1.)

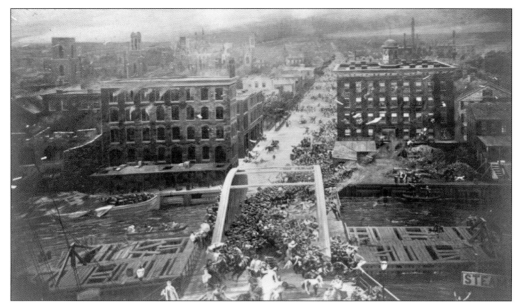

This photograph is part of a huge cycloramic painting of the fire, which was displayed in a large round theater on Michigan Avenue from 1892 until the close of the 1893 World's Columbian Exposition. The canvasses were 50 feet high and covered 20,000 square feet. They were sold to a junk dealer in 1913 for $2. (Courtesy Library of Congress, Prints and Photographs Division, LC-USZ62-40300.)

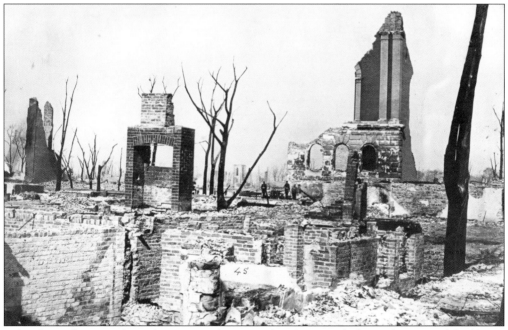

Taken by William Letchworth in November 1871, this photograph shows the ruins of the library building of the Chicago Historical Society. The building stood on the north side of Ontario Street, between Clark and Dearborn Streets. The photograph was donated to the Chicago Historical Society by the Buffalo Historical Society in January 1925. (Courtesy Chicago History Museum, ICHi02770.)

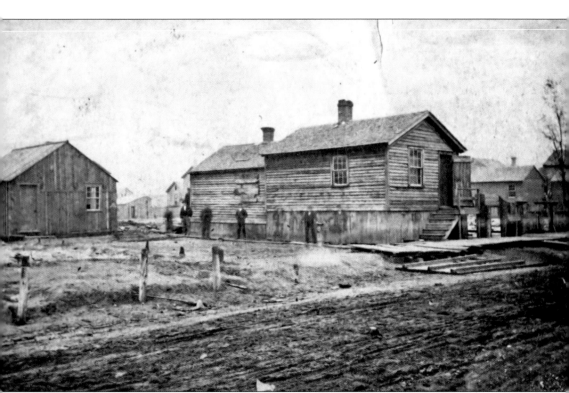

This photograph was taken shortly after the fire and shows the O'Leary home at 137 DeKoven Street in what was called "the West Division." It was amazing that the house was spared; the barn where the fire started was completely destroyed. The one seen here at left is not the original barn, but another built later. The Chicago City Council finally cleared O'Leary and her cow in October 1997. (Courtesy Chicago History Museum, ICHi02737.)

Three

PESHTIGO PARADIGM

Although the Great Chicago Fire of 1871 received most of the press, there were many other cataclysmic fires that occurred on October 8–10, 1871.

One of the deadliest fires to occur during this time was surprisingly not Chicago's. North of Green Bay, Wisconsin, was the relatively small city of Peshtigo, Wisconsin. In 1871, Peshtigo had about 2,000 residents and was primarily a logging town. The town was decimated by a fire that occurred at relatively the same time as the one in Chicago. One of the big differences was that while Chicago claimed a loss of life somewhere around 300, Peshtigo lost between 800 to 1,200 people. The fire was so hot and fast in Peshtigo that people remember seeing strange black balls hovering over people as they walked through an open field, and as soon as the ball was above them, they would be incinerated. One person was trying to escape the flames with his family in a wagon. The wagon broke a wheel, and he jumped off the wagon in an attempt to fix it. The flames rushed by, and when he returned to the wagon, his family was burned to death.

Lake Michigan itself seemed helpless in sheltering the state of Michigan from the fires plaguing Illinois and Wisconsin.

The cities of Holland and Manistee, Michigan, were utterly destroyed by the fire, although the death toll was much lower. Between Manistee and Holland, there was only one reported death. Destruction totals were in the millions of dollars, however, and thousands of people were left homeless and stunned.

Much farther east in what is called the "thumb" of Michigan, the same types of fires caused untold damage to the area in and around Port Huron.

Many theories, including that of a comet debris field, have been discussed, but after years of debate, the answer is still elusive. The general consensus, though, is that a dryer than average October coupled with strong winds out of the southwest came together in a perfect firestorm.

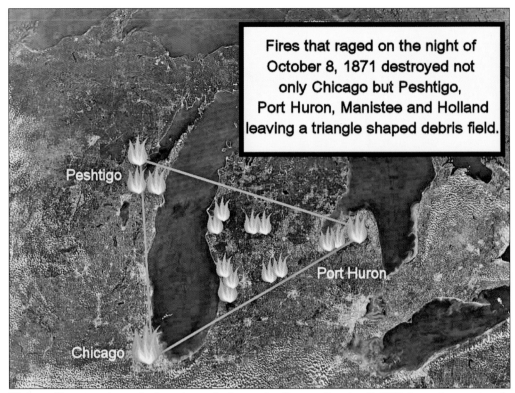

Fires that raged on the night of October 8, 1871 destroyed not only Chicago but Peshtigo, Port Huron, Manistee and Holland leaving a triangle shaped debris field.

This satellite view shows the locations of other major fires on October 8, 1871, in a tristate triangle known as "the Peshtigo Paradigm." One theory that explains how these firestorms erupted at the same time in locations so far apart is the comet theory. A comet named Biela had been observed to split into two fragments named Biela-1 and Biela-2. One of them burned up in the atmosphere on October 8, 1871, possibly releasing methane and other gasses, which, when combined with oxygen, can create intense fires. (John Boda.)

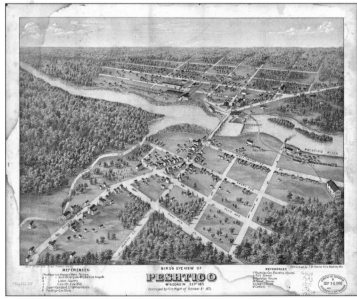

In 1871, there were approximately 2,000 people living in Peshtigo and nearby areas. The town was on both sides of the Peshtigo River and covered about one square mile. The fire started a few minutes past 9:00 p.m. on Sunday, October 8, 1871—the same night and almost the exact time of the Chicago fire. (Courtesy Library of Congress Geography and Map Division, G4124.P3A3 1871.T2.)

This photograph shows the Peshtigo Dock at Green Bay. Many people are amazed that the Chicago fire jumped the Chicago River twice, but in Peshtigo it appears to have jumped Green Bay, and if this theory is true, it appears the huge tristate fire jumped Lake Michigan as well.

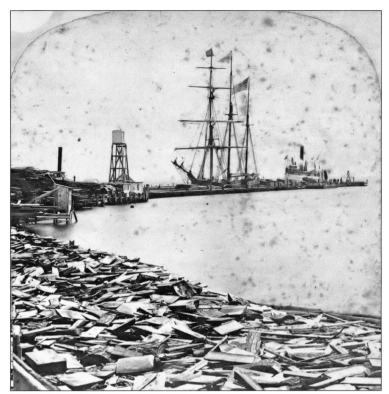

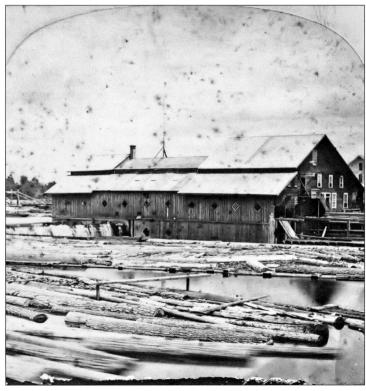

The Peshtigo Company was a thriving business with a sawmill, boardinghouse, and 700 mill workers. It was owned by William Butler Ogden of Chicago and Isaac Stephenson of Marinette. Ogden (Chicago's first mayor, 1837) purchased the existing sawmill in Peshtigo in 1856. He would end up losing nearly $3 million between his properties in Chicago and Peshtigo after the fires.

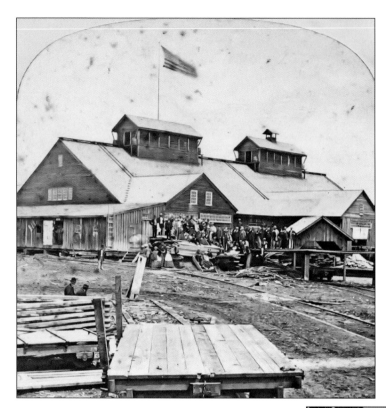

Originally called Clarksville, the town's name was changed to Peshtigo, after the river that divides it. The main industry was logging the forests of white pine trees, and it was estimated there were one billion trees covering a one-million-acre area. Ironically, many of these trees produced the wood for the Chicago homes that would all burn down on October 9, 1871.

The Peshtigo Fire Museum is on the site where a Catholic church once stood; the church was lost in the fire. The building itself is actually the old Congregational Church, the first church built after the fire. It was moved to this location in 1927 after the rebuilt Catholic church was again lost in a fire. The Peshtigo Fire Museum has used the building since 1963. (Ray Johnson.)

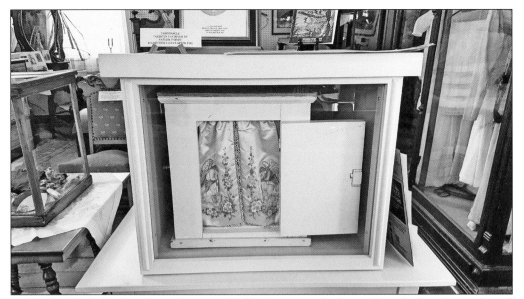

While the Catholic church was burning, Father Pernin rushed outside with the tabernacle and placed it in the river to keep it from burning. The tabernacle was recovered from the river three days later. It is now in the care and custody of the Peshtigo Fire Museum. (Ray Johnson.)

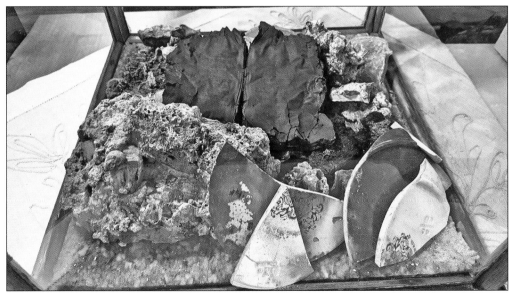

As with the inferno in Chicago, there were many strange relics of the fire recovered in Peshtigo. Among the relics in this photograph is a charred Bible, which can still be read. It was found near the remains of the town drugstore. The pages are open to Psalm 106 and 107, which talk about God never deserting his people regardless of their actions and trials. (Ray Johnson.)

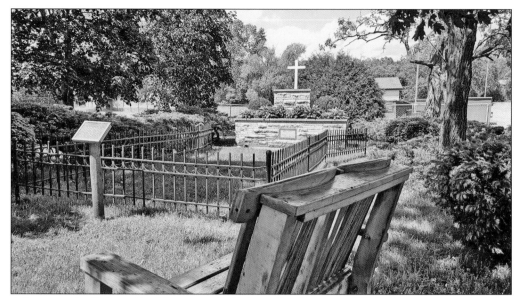

Adjacent to the Peshtigo Fire Museum is the Peshtigo Fire Cemetery. While Chicago claimed to have lost approximately 300 lives, Peshtigo lost at least 800—some say upwards of 1,200—residents. There is a mass grave to the almost 350 people whose bodies could not be identified. (Ray Johnson.)

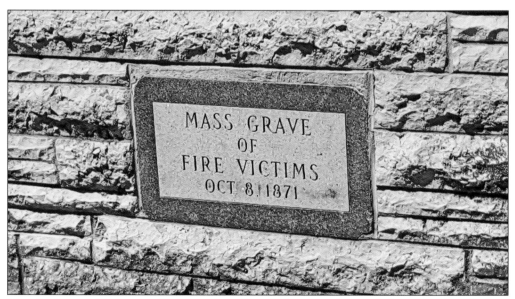

Most bodies could not even be located or identified, as people simply became piles of ashes, identifiable only by a ring, buckle, or something that survived the incredible heat. Other victims were found bearing no traces of burns or scars and appeared to be sleeping, but had suffocated. However, inside their pockets were found metal objects, such as watches and coins, completely melted. (Ray Johnson.)

William Butler Ogden was Chicago's first mayor, the founder of the Chicago Board of Trade, the leading promoter and investor of the Illinois and Michigan Canal, and helped build several railroads. He also founded and owned the Peshtigo Company, with a sawmill and woodenware factory, in Peshtigo. After the fire devastated both Chicago and Peshtigo, he lost an estimated $3 million. (Authors' collection, original gifted to Chicago History Museum.)

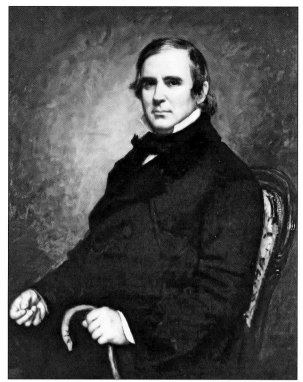

The following three photographs show the city of Manistee, Michigan, shortly before the devastating fire that hit the city the morning of October 8, 1871. Here, the city's Second Ward is seen in the foreground as well as the swing bridge crossing the Manistee River at Maple Street. (Courtesy Manistee County Historical Society.)

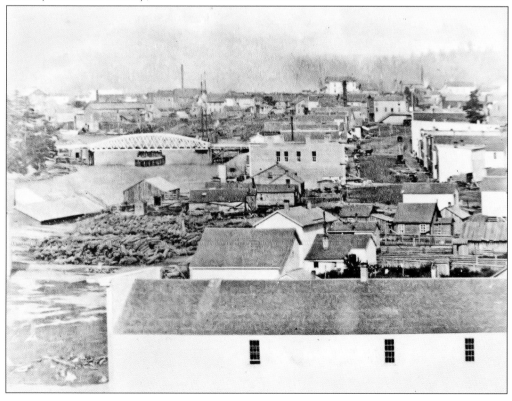

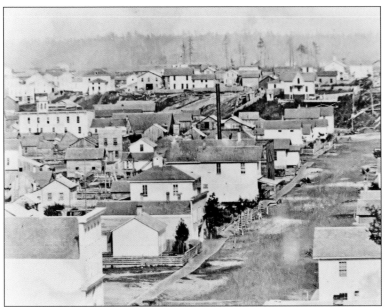

This photograph also shows the city's Second Ward, which was south of the Manistee River and closest to Lake Michigan. Six platted blocks and 30 other various buildings were destroyed in the Second Ward, while the Third Ward, seen in the distance and east of the bridge, was totally destroyed. (Courtesy Manistee County Historical Society.)

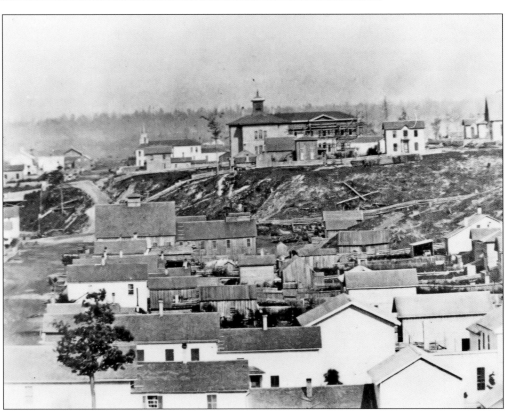

This third photograph in the series continues to show the Second Ward in the foreground and the Third Ward in the background. Farther south (to the right) and closer to Lake Manistee was the Fourth Ward, which was left in good condition. Before the fire was over, 1,000 people were homeless, but incredibly, no one lost their life. (Courtesy Manistee County Historical Society.)

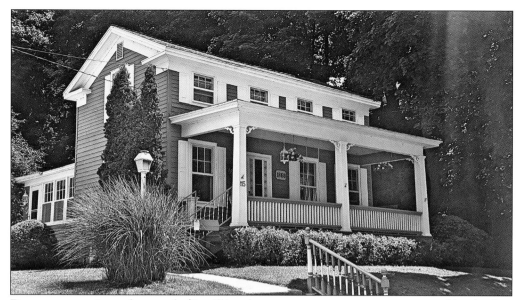

Damage was estimated at nearly $1 million; however, some structures were spared by the fire. This frame residence still exists and was part of the Second Ward of Manistee, which was more in the center of town and in the area that was considered to be more well built. The residence dates to 1868. (Ray Johnson.)

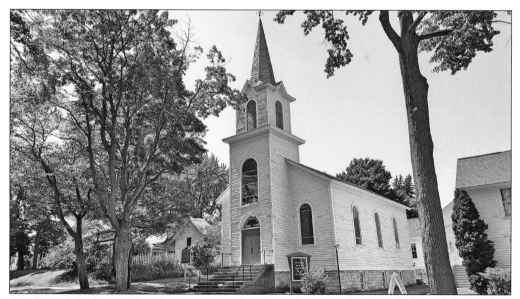

Our Savior's Lutheran Church was organized as a Scandinavian church in 1868, and the building was first used for worship in 1869. The building survived the fire despite being in one of the most heavily damaged sections of the city. It became a Danish American Evangelical Lutheran church in 1875. It is located at 304 Walnut Street and is today the Danish American Museum. (Ray Johnson.)

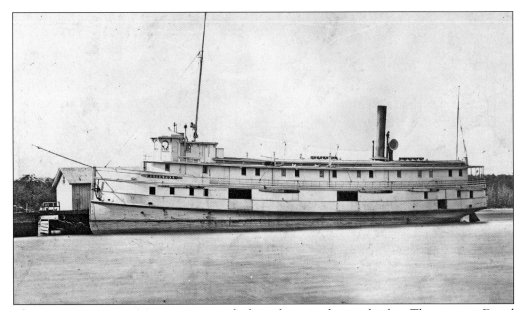

The passenger steamer *Messenger* was at dock in the river during the fire. The captain, David Cochrane, rushed as many people as he could onto the ship. The flaming bridge on Maple Street was on fire, though, blocking his exit. As the bridge collapsed, he pushed through the flaming timbers and brought his passengers to safety on Lake Manistee. (Courtesy Loutit District Library.)

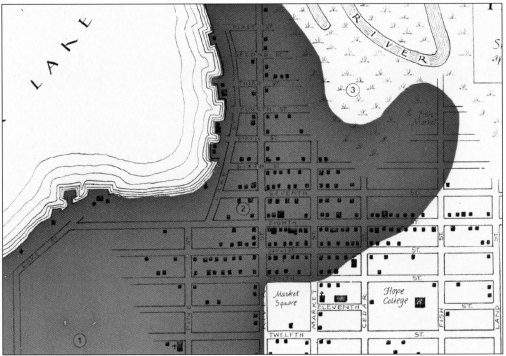

The city of Holland was formed in 1847 by Dutch immigrants looking for religious freedom. By 1871, it had a population of roughly 2,400. The fire that began on the evening of October 8, 1871, destroyed 80 percent of the property with lightning speed. Most escaped death by taking to boats in Black Lake. (Courtesy Joint Archives of Holland, H97-PH7100.1.)

While no photographs exist of any of the 1871 fires, there were plenty of artist renderings. This sketch, drawn by Dirk Gringhuis, was from a local news clipping and gave readers an idea of how fast the flames were moving and how people escaped with only a small portion of their possessions. (Courtesy Joint Archives of Holland, H88-PH7100.)

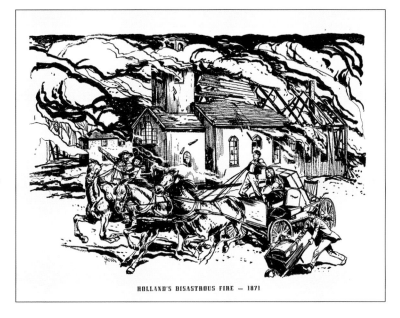

HOLLAND'S DISASTROUS FIRE — 1871

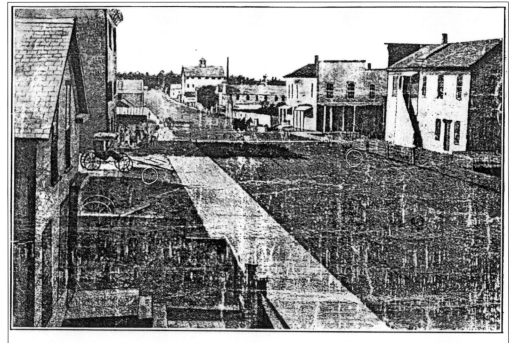

Holland during the war times, River Street looking north, intersected by Eighth Street

Photographs of Holland before the fire are rare; this one was taken during the Civil War. The fire devastated this small community, and damages were estimated at upwards of $900,000. Over 300 people were left homeless, but only one life was lost. Hope College was also spared and is still in operation. (Courtesy Joint Archives of Holland, H96-PH7141.)

85

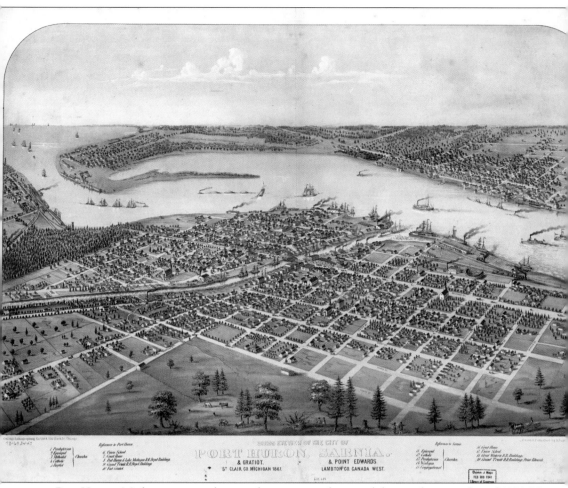

Port Huron, Michigan, was only one of many areas destroyed during the great fire of 1871. Near the shore of Lake Huron were Glen Haven, White Rock, Forestville, Sand Beach, Port Hope, Elm Creek, Huron City, Forest Bay, Center Harbor, Rock Falls, and Verona Mills. Each area had 200–600 residents and all where left virtually destroyed. (Courtesy Library of Congress Geography and Map Division, G4114.P7A3 1867.R8)

Four

POSTFIRE CHICAGO

When the fire finally stopped, there were huge issues to deal with, such as the nearly 100,000 new homeless people. Many gathered at Lincoln Park simply because they had nowhere else to go. There were needs of food and shelter, and the entire city was left without water when the waterworks burned. A Civil War hero, Gen. Philip Sheridan, was given authority to patrol the streets with federal troops to maintain control. But it did not take long before ambitious residents took action to restore their homes and lives.

It is not an exaggeration to say that while Chicago was still smoking, some began to rebuild. One of the first was the real estate office of William Kerfoot, who painted a sign on his new shanty that said, "All gone but wife, children, and energy."

The fire had just ended during the early morning hours of Tuesday, October 10, 1871, and later that same afternoon, the stockholders of the chamber of commerce resolved to rebuild at once. In just over three weeks, Field, Leiter & Company (later Marshall Field's) was back in business in a remolded barn at Twentieth and State Streets. About the same time, the famous Palmer House was being rebuilt from the original plans of Chicago's first architect, John M. Van Osdel. Many more followed.

Two years after the fire in 1873, Chicago's *Land Owner* published a second anniversary edition in which the editor stated, "In the past eighteen months more than a thousand major buildings having a total value of more than $50,000,000 had been erected. Today the city is practically rebuilt." He also added, "[Chicago] is now a better, more artistic, grander city than the old Chicago that fed the flames." By 1875, there were hardly any traces of the fire left.

After the fire, Chicago's population grew even more rapidly than before, rising from 300,000 in 1870 to 500,000 by 1880. By the time of the 1893 World's Columbian Exposition, it had reached one million people.

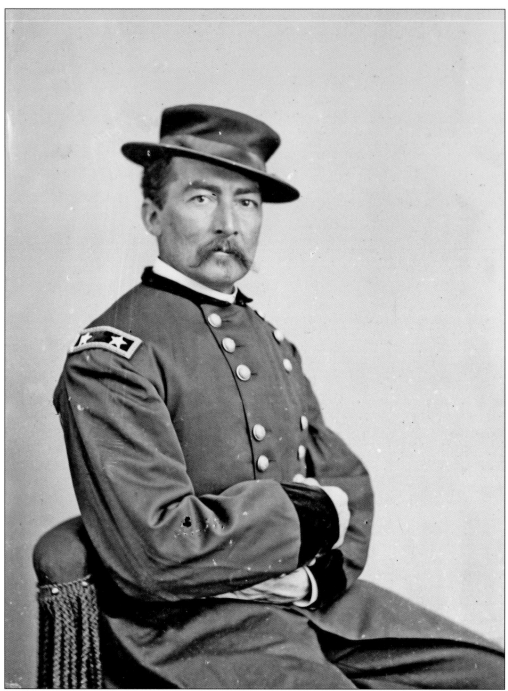

Shortly after the fires burned out, the process of rebuilding started almost immediately. Mayor Roswell B. Mason requested the assistance of the federal government in anticipation of large-scale panic and unrest. Martial law was declared, and Gen. Philip Sheridan was placed in charge. While the Army's presence gave Chicagoans a sense of security, the lack of lawlessness caused the lifting of martial law within a few days. (Courtesy Library of Congress, Prints and Photographs Division, Brady-Handy Collection, LC-BH82-4012C.)

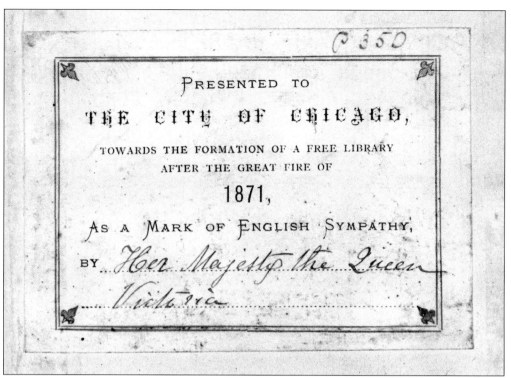

PRESENTED TO

THE CITY OF CHICAGO,

TOWARDS THE FORMATION OF A FREE LIBRARY
AFTER THE GREAT FIRE OF

1871,

AS A MARK OF ENGLISH SYMPATHY,

BY *Her Majesty the Queen Victoria*

Following the great fire, donations of money and products poured into Chicago from all over the world. One such donation came from Queen Victoria and the citizens of Great Britain in the form of books, donated to form what is now the Chicago Public Library. (Courtesy Chicago Public Library Special Collections and Preservation Division.)

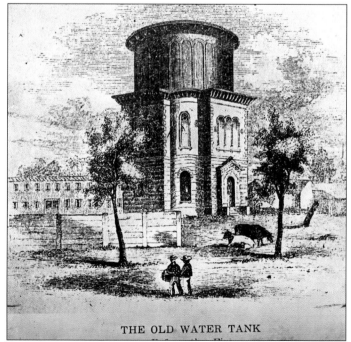

THE OLD WATER TANK

This engraving shows the water tank that stood at the southeast corner of LaSalle and Adams Streets before the fire. The Chicago Public Library's first home was in this tank following the fire, and it opened on January 1, 1873. It was also city hall until the new city hall was erected in 1885. (Courtesy Chicago Public Library Special Collections and Preservation Division.)

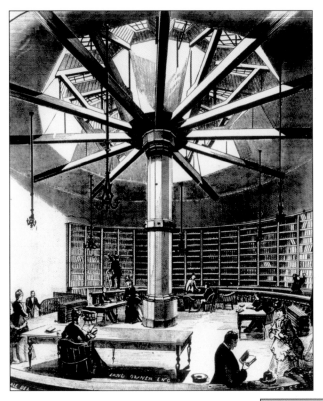

The water tank that housed the Chicago Public Library's collection was 58 feet in diameter and 28 feet high. Best of all, it was fireproof. The dilapidated building surrounding it was used as an interim city hall, and citizens started complaining about the pigeons roosting there, nicknaming it "The Rookery," which was adopted by the structure that now stands in its place. (Courtesy Chicago Public Library Special Collections and Preservation Division.)

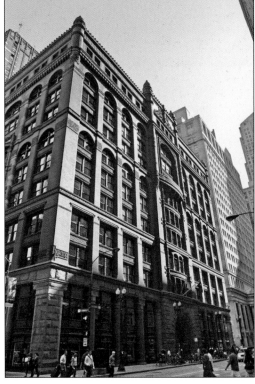

The Rookery Building was designed by the famed Chicago architectural firm of Burnham & Root and was completed in 1888. The building still stands on the southeast corner of LaSalle and Adams Streets as an impressive tribute to the architectural revival of the city following the fire of 1871. Its lobby was redesigned by architect Frank Lloyd Wright in 1905. (Ray Johnson.)

This first permanent home of the Chicago Public Library was finished in 1897. Designed by Shepley, Rutan & Coolidge, it is four stories tall. It stands on the northwest corner of Michigan Avenue and Randolph Street and is now the home of the Chicago Cultural Center. The building boasts the largest Louis Comfort Tiffany glass dome in the world, at 38 feet in diameter. (Courtesy Library of Congress, Prints and Photographs Division, Detroit Publishing, LC-D4-12406C.)

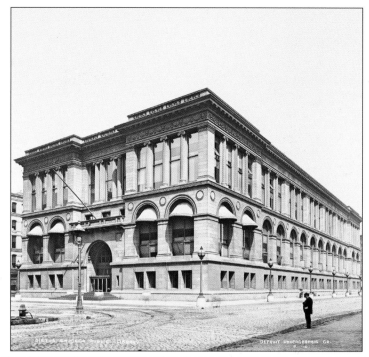

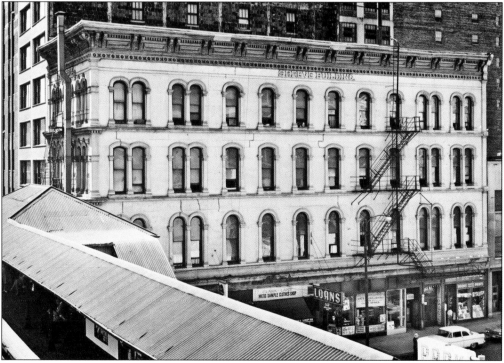

Typical architecture and building materials used after the fire were found in the Shreve Building, constructed in 1875. It stood at 100–104 West Lake Street. W.W. Boyington, who designed the Chicago Water Tower, supervised its construction. (Courtesy Library of Congress, Prints and Photographs Division, HABS ILL, 16-CHIG, 32—1.)

The Washington Block was completed in 1874 and was very similar in construction to the Shreve Building. The architects were Frederick and Edward Baumann, and at the time of its construction, it was one of the tallest buildings in Chicago after the fire. The building had an isolated pier foundation that led to the development of the modern high-rise. The building, with its curved hardwood staircase, still stands at the southwest corner of Washington and Wells Streets. (Ray Johnson.)

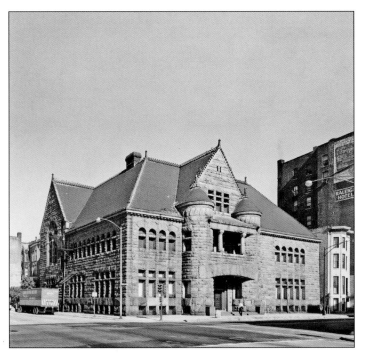

The Chicago Historical Society was formed in 1856, and its first building burned in the fire of 1871. The building seen here is actually its third home, constructed in 1892 and designed by famed architect Henry Ives Cobb. After the historical society moved to Lincoln Park in 1931, this was a series of nightclubs. It still exists today in the same location as the first building, at the northwest corner of Dearborn and Ontario Streets. (Courtesy Library of Congress, Prints and Photographs Division, HABS ILL, 16-CHIG, 13—1.)

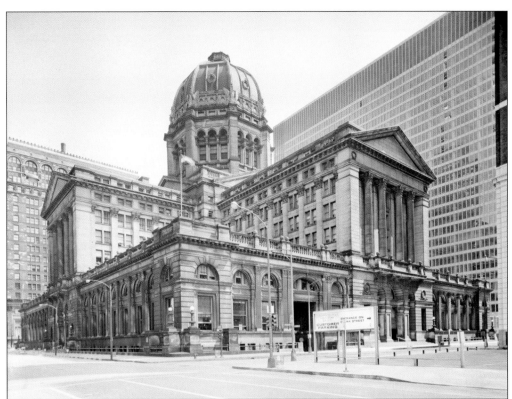

The Chicago Federal Building was formerly the Chicago Post Office. It was finished in 1905 with Henry Ives Cobb as the architect. It stood on the block of West Jackson, South Clark, West Adams, and South Dearborn Streets. It was eight stories tall with a basement and dome. The building stood until 1966 and was replaced by a modern US Post Office on the same block. (Courtesy Library of Congress, Prints and Photographs Division, HABS ILL, 16-CHIG, 89—1.)

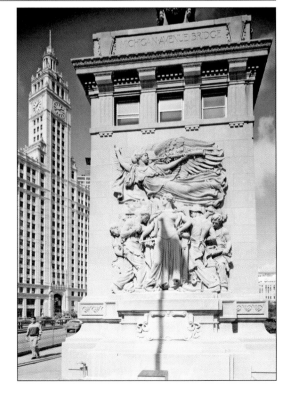

The Michigan Avenue bascule bridge, which opened to traffic in 1920, has sculptures on the outward-facing walls of its four bridge houses. One of those sculptures, commissioned by the B.F. Ferguson Monument Fund and completed by Henry Hering, is called *Regeneration* and depicts workers rebuilding the city after the fire of 1871. (Courtesy Library of Congress, Prints and Photographs Division, HAER ILL, 16-CHIG, 129—11.)

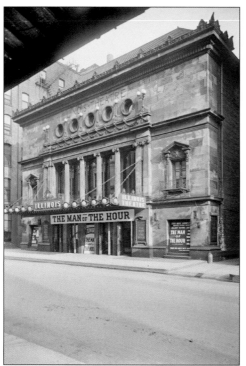

The Illinois Theater stood at 65 East Jackson Street from 1900 until 1936 and was designed by Wilson and Marshall. It stood on the site previously occupied by the 1st Regiment Infantry Armory. (Courtesy Library of Congress, Detroit Publishing Company, LC-D4-34702.)

The name "Chicago Coliseum" goes back to the Civil War era; however, this was the third incarnation of the Chicago Coliseum. The castle-like wall is actually a wall from the Libby Confederate Prison, which was moved from Richmond, Virginia, to Fifteenth and Wabash Avenues in Chicago by Charles F. Gunther to create the Libby Prison War Museum in 1889. The prison was torn down in 1899, and the Chicago Coliseum was built around the remaining wall. It hosted, among many other things, Chicago's notorious First Ward Balls, five consecutive Republican National Conventions, and the Chicago Blackhawks. The building was demolished in 1982. (Courtesy Library of Congress, Detroit Publishing Company, LC-D4-39418.)

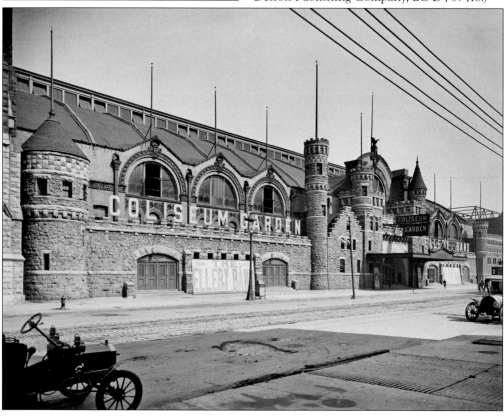

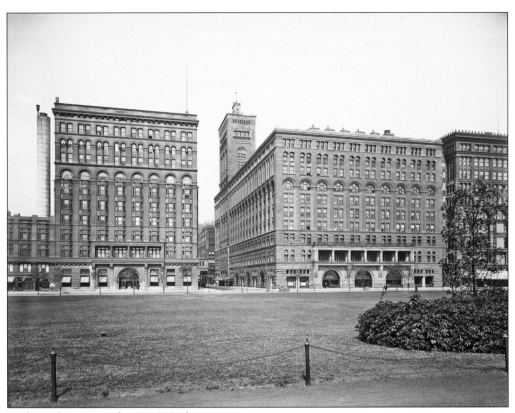

Dedicated on December 9, 1889, the Auditorium Building (right) was designed by Adler & Sullivan with Paul Mueller as the engineer. It is located at 430 South Michigan Avenue and is now part of Roosevelt University. The building is 10 stories high with an 18-story tower and houses one of the largest opera houses in the world. The building at left is the Auditorium Annex, which was constructed in 1893. It is now the Congress Plaza Hotel and Convention Center. (Courtesy Library of Congress, Detroit Publishing Company, LC-D4-12620.)

The Great Northern Hotel was built in 1892 and designed by Burnham & Root. It stood at the northeast corner of Jackson and Dearborn Streets and was 16 stories high. The structure was built up by nine inches in order to accommodate settling. It was demolished in 1940. The Dirksen Federal Center now occupies the site. (Courtesy Library of Congress, Detroit Publishing Company, LC-D4-12550.)

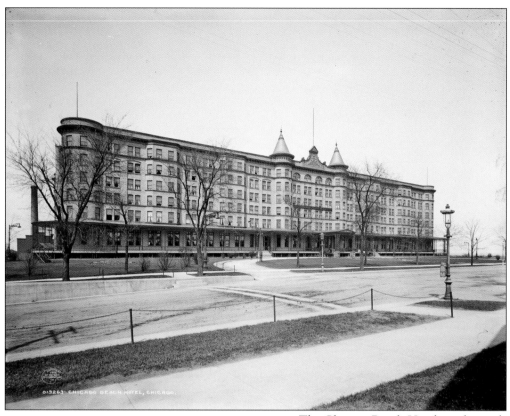

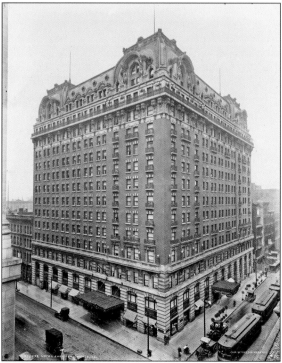

The Chicago Beach Hotel was located at 1660 East Hyde Park Boulevard in the Kenwood community of Chicago. It was built in 1892 and was one of the many hotels built to accommodate visitors to the 1893 World's Columbian Exposition. It had beachfront access until 1920, when the city used fill to create South Lake Shore Drive. The hotel was demolished in 1927. (Courtesy Library of Congress, Detroit Publishing Company, LC-D4-13262.)

The Hotel Sherman, pictured here, replaced the three Sherman Houses before it in the same location. The second Sherman House burned in the Chicago fire, and the third was replaced by this Hotel Sherman in 1911. Holabird & Roche were the architects. This photograph shows the six stories that were added in 1920. (Courtesy Library of Congress, Detroit Publishing Company, LC-D4-72292.)

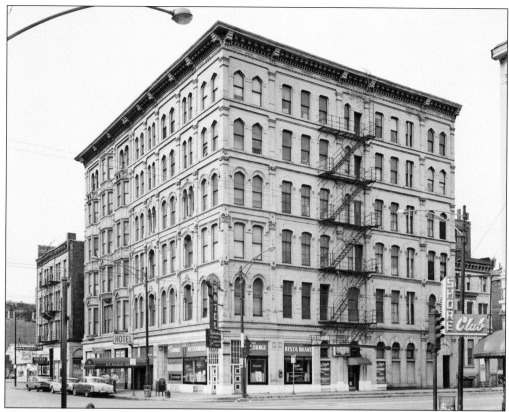

The Palace Hotel was built in 1875 at the southwest corner of North Clark Street and West Grand Avenue. It was previously known as both the Grand Palace Hotel and the St. Regis Hotel. In 1985, it was converted to office space and stands in the same location today. (Courtesy Library of Congress, Prints and Photographs Division, HABS ILL, 16-CHIG, 59—1.)

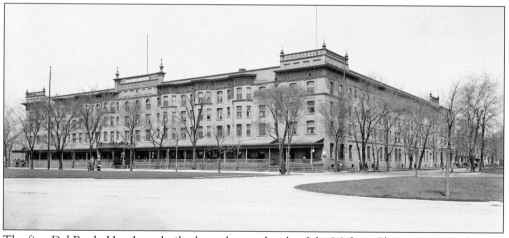

The first Del Prado Hotel was built along the north side of the Midway Plaisance. It was located on Fifty-Ninth Street between Dorchester and Blackstone Avenues, and was built to accommodate the guests expected to flood Chicago during the 1893 World's Columbian Exposition. This Hyde Park hotel was razed over 100 years ago to make room for the International House, Windermere West. (Courtesy Library of Congress, Detroit Publishing Company, LC-D4-13265.)

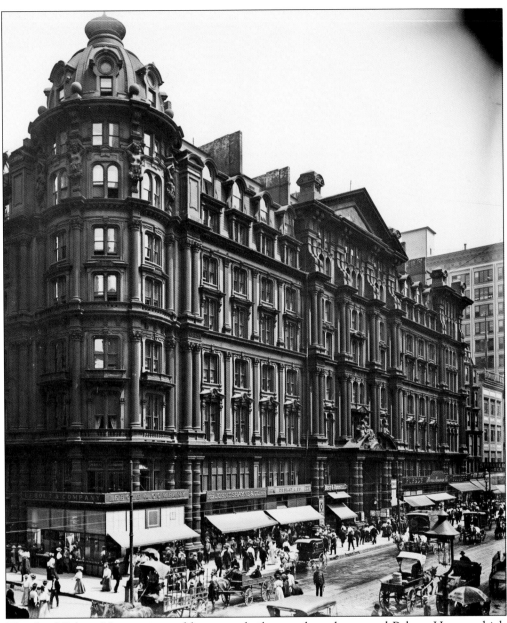

The third Palmer House, pictured here, was built to replace the second Palmer House, which burned in the great fire. The second Palmer House opened only two weeks before the fire and was meant as a wedding gift to Potter Palmer's wife, Bertha Palmer. The architect was John M. Van Osdel, and the story was told how Van Osdel buried the plans of the second Palmer House beneath the building, which preserved them through the fire. This Palmer House opened in 1875 and was torn down in stages from 1925 to 1928 while the current Palmer House was being built, which enables the hotel to retain the title of the longest continuously operating hotel in America. (Courtesy Library of Congress, Detroit Publishing Company, LC-D4-70156.)

The Exposition Building was finished in 1873 on South Michigan Avenue and Adams Street. W.W. Boyington was the architect. It was also known as the Chicago Opera Festival Auditorium and as the Interstate Exposition Building. It was razed in 1892 to make way for the building that now houses the Art Institute of Chicago.

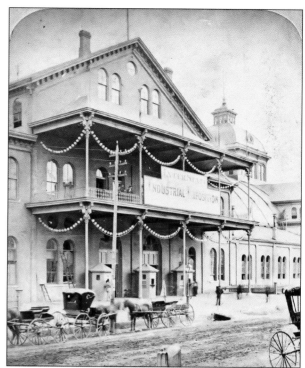

The Victoria Hotel, also known as the Beaurivage Bachelor Apartments, was built in 1875 at the corner of South Michigan Avenue and East Van Buren Street. It was razed in 1908 to make room for the current McCormick Building, which was completed in 1910. (Courtesy Library of Congress, Detroit Publishing Company, LC-D4-13264.)

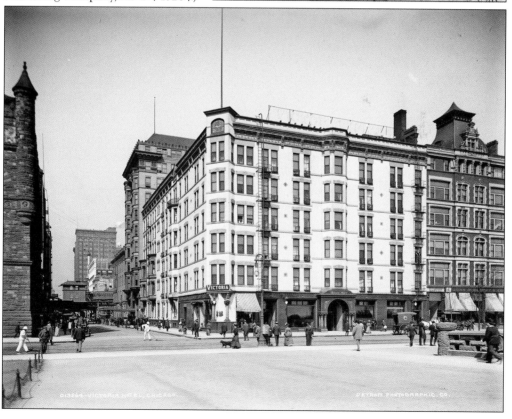

The building that now houses the Chicago Athletic Association Hotel at 12 South Michigan Avenue was in 1893 the home of the Chicago Athletic Association. The building was designed by Henry Ives Cobb, who also designed the Fisheries Building at the 1893 World's Columbian Exposition and was a swindle victim of Dr. H.H. Homes, made famous by Erik Larson's best-selling book *Devil in the White City*. Interestingly, there was a devastating fire during construction in November 1892, but the building survived and remains to this day. (Courtesy Library of Congress, Detroit Publishing Company, LC-D4-18835.)

The first combined city hall and county building was erected on the site of the present city hall and county building in 1885. The library occupied the fourth floor until its first permanent home was erected at the corner of Randolph Street and Michigan Avenue, today's Chicago Cultural Center. The current combination city hall and county building was erected in 1911 and is on the same site. (Courtesy Chicago Public Library Special Collections and Preservation Division.)

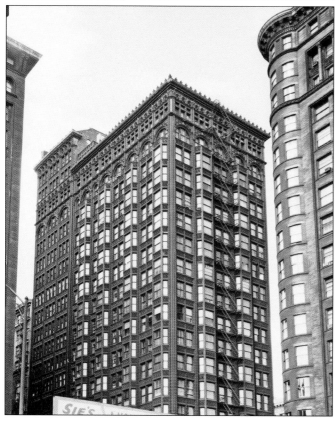

The Fisher Building was constructed in 1896 on the northeast corner of West Van Buren and South Dearborn Streets. It was designed by Charles Atwood, who also created the Palace of Fine Arts (among other buildings) at the 1893 World's Columbian Exposition. He designed it for D.H. Burnham & Co. architects. The builders claimed a rapid steel erection record of 13.5 stories in 14 days. The building stands today in the same location. (Courtesy Library of Congress, Prints and Photographs Division, HABS ILL, 16-CHIG, 80—1.)

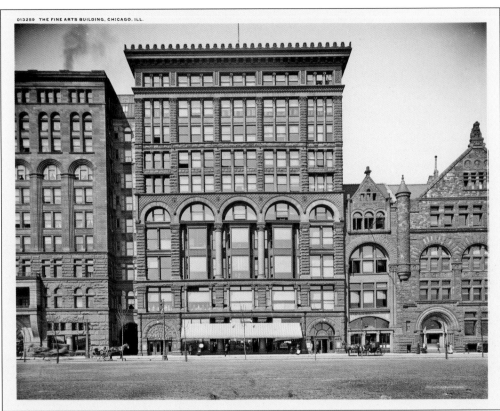

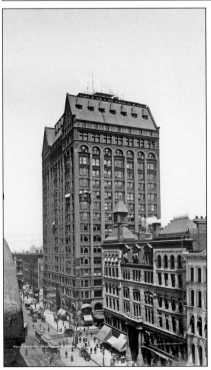

The Fine Arts Building was constructed in 1886 as the Studebaker Wagon Repository. It was designed by Solon Spencer Beman, who also created the Merchant Tailors Building for the 1893 World's Columbian Exposition and the Blackstone Branch of the Chicago Public Library in the Kenwood community area of Chicago. In 1895, the tenants primarily consisted of those involved in the fine arts. Beman removed the top (eighth) floor of the building in 1898 and added three stories. The building remains at 410 South Michigan Avenue. (Courtesy Library of Congress, Detroit Publishing Company, LC-D4-13259.)

The Masonic Temple, also known as the Capitol Building, was finished in 1892 and designed by Burnham & Root. It stood at the northeast corner of North State and East Randolph Streets. At 21 stories and 321 feet tall, it was the tallest building in the world when finished. The meeting rooms at the top of the building were for Masonic meetings and also served as theaters. The elevators were not adequate to serve the theater patrons and tenants, and the building fell out of favor. It was razed in 1939. (Courtesy Library of Congress, Detroit Publishing Company, LC-D4-12617.)

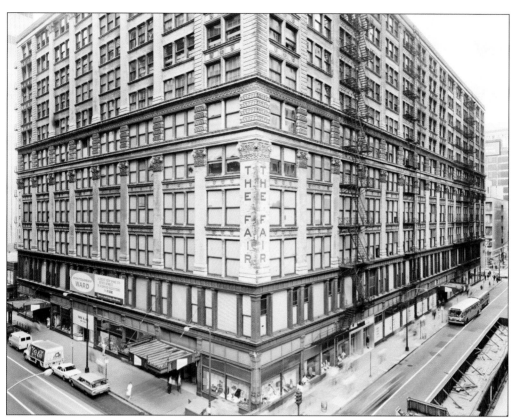

E.J. Lehman's The Fair store was at the northwest corner of South State and West Adams Streets in 1892. It was nine stories tall and had two stories added later. The eastern half of the building was constructed in 1896, and at 500,000 square feet, it was advertised as the world's largest department store. It was known as a discount department store, and Lehman was one of the first to use pricing that was not in multiples of five in order to save customers a few pennies. The architects were Jenney & Mundie, and the building was razed in 1984. (Courtesy Library of Congress, Prints and Photographs Division, HABS ILL, 16-CHIG, 62—1.)

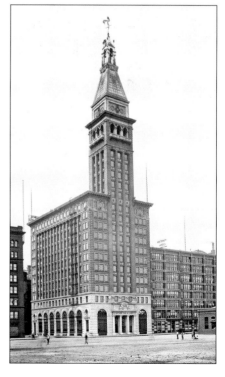

The building at 6 North Michigan Avenue was constructed in 1899 at a height of 12 stories with a 394-foot tower for the headquarters of the Montgomery Ward Company. The architect was Richard E. Schmidt. The huge weather vane atop the structure was named "Progress Lighting the Way for Commerce" and was set on October 20, 1900. The building remains, but the tower and vane were removed in 1947 for safety reasons. (Courtesy Library of Congress, Detroit Publishing Company, LC-D4-14730.)

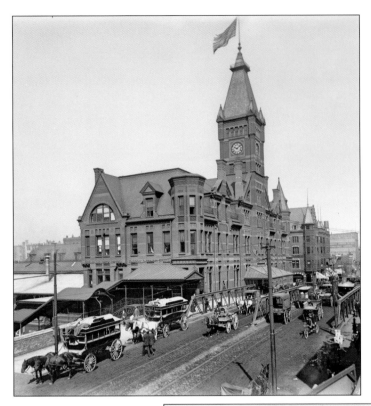

The original Wells Street Station was destroyed in the fire, and a temporary one was used until this station was erected in 1882 on the same location. The station was located at the southwest corner of North Wells and West Kinzie Streets and remained until 1927. The Merchandise Mart took its place in 1930. (Courtesy Library of Congress, Detroit Publishing Company, LC-D4-4857.)

The Dearborn Station, also called the Polk Street Station, was built in 1883 on Polk Street, at the foot of South Dearborn Street. Cyrus L.W. Eidlitz was the architect. It was owned by the Chicago & Western Indiana Railroad. After a fire in 1922, the peak roof design had to be modified. The train sheds were razed in 1976. The building still exists and is currently used for retail and office space. (Courtesy Library of Congress, Detroit Publishing Company, LC-D4-72294.)

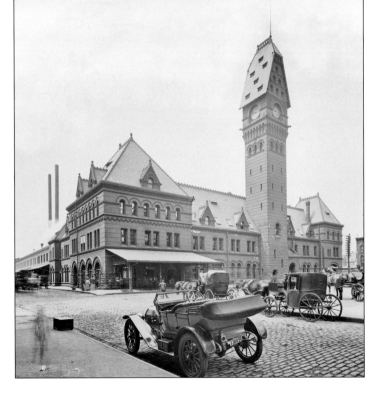

The Illinois Central Railroad station was completed in 1892, with Bradford L. Gilbert as the architect. It was located east of South Michigan Avenue and East Twelfth Street, just south of the current Grant Park. The building was seven stories high with a 13-story clock tower. It opened on April 17, 1893, to serve passengers going to the 1893 World's Columbian Exposition. It boasted the largest train shed in the world. The building was demolished in 1974. (Courtesy Library of Congress, Detroit Publishing Company, LC-D4-13260.)

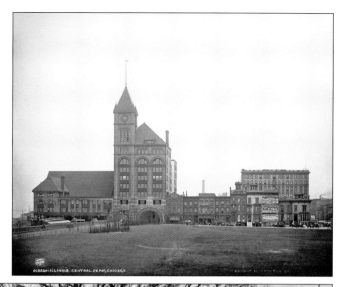

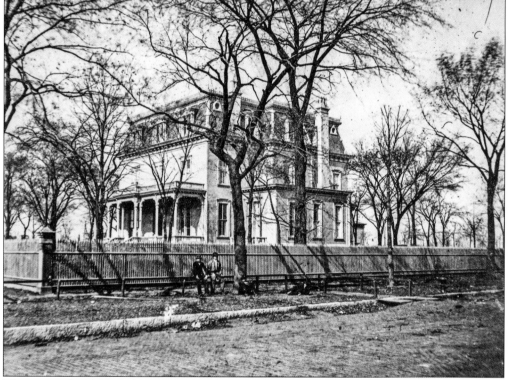

The younger brother of Chicago's first mayor, William B. Odgen, purchased the property just north of Washington Park and built his house in 1856. Mahlon D. Odgen was a prosperous attorney as well as being a probate judge for a number of years. Due to the fact that there were a good number of trees to the south in Washington Park and a good amount of space around his house, coupled with the efforts of his family, his frame house became known as the only residence in the path of the fire that survived. Mahlon Odgen died on February 13, 1880, and his home was occupied by Potter Palmer and then by the Union Club before the Newberry Library took its place in 1893. (Courtesy of Newberry Library.)

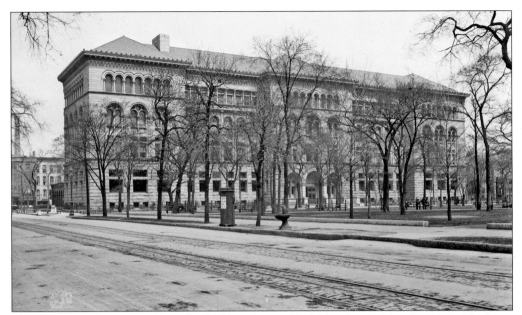

The Newberry Library moved into this building designed by Henry Ives Cobb in 1893. The Newberry Library was founded in 1887 due to a bequest by Chicago land developer Walter Loomis Newberry, who died at sea in 1868. Newberry is buried at Chicago's Graceland Cemetery. The Newberry Library became dedicated to the humanities and today has a world-renowned collection of books, manuscripts, maps, and other materials related to the history and culture of Western Europe and the Americas. (Courtesy Library of Congress, Detroit Publishing Company, LC-D4-13257.)

Looking at the recreational children's beach at Lincoln Park in 1905, it is hard to imagine that roughly 30 years prior, the terrified citizens of Chicago were crossing the park, which at the time was mostly the City Cemetery, and wading into the same waters in order to escape the scorching flames of the Great Chicago Fire. (Courtesy Library of Congress, Detroit Publishing Company, LC-D4-18837.)

George M. Pullman built his residence at 1729 South Prairie Avenue. He hired architect Henry S. Jaffray to design the house, and Pullman and his wife, Harriett, moved into the home in January 1876. Pullman was an industrialist and inventor of the Pullman sleeping car. He also founded the company town of Pullman, which is now a historic landmark. The home was 7,000 square feet and included a theater, billiard room, pipe organ, and bowling alley. The property was demolished in 1922. (Courtesy Library of Congress, Detroit Publishing Company, LC-D4-12551.)

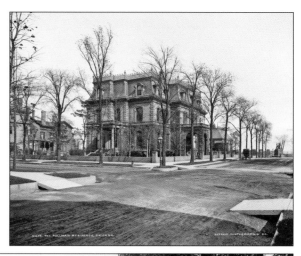

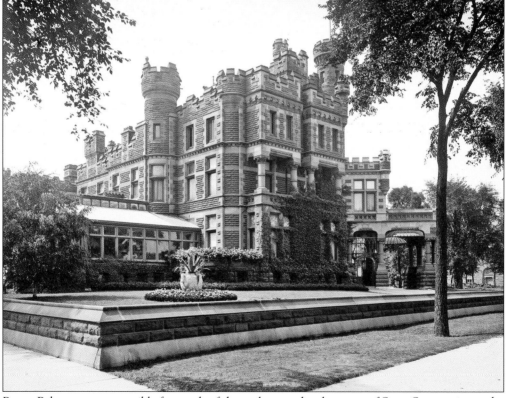

Potter Palmer was responsible for much of the real estate development of State Street prior to the 1871 fire, and after it as well. In 1882, he hired Henry Ives Cobb and Charles Sumner Frost to design a residence for him and his wife, Bertha Palmer, at 1350 North Lake Shore Drive. It was once the largest residence in Chicago. After five years of construction, the residence cost the Palmers over $1 million. The architects referred to its style as Early Romanesque, and it was based off the design of a German castle. It featured many parlors, and its grand ballroom had paintings collected by Bertha Palmer, which were donated to the Art Institute of Chicago following her death in Sarasota, Florida. The house was razed in 1950. (Courtesy Library of Congress, Detroit Publishing Company, LC-D4-12409.)

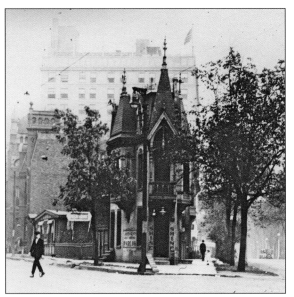

The Relic House was a very odd structure that existed shortly after the fire and was constructed entirely out of relics of the Great Chicago Fire. Its materials consisted of masses of melted metal, glass, and stone and various other materials. It was moved from its original location to a spot on North Clark and Centre Streets, near the entrance to Lincoln Park. At one point, it housed a restaurant, hall, and saloon. It later became the house of a medium named Madam Rose, who called it La Rose College of Psychology. Finally, the entire block it sat on was purchased by Peter F. Reynolds and razed in 1929. (Courtesy Chicago Public Library Special Collections and Preservation Division.)

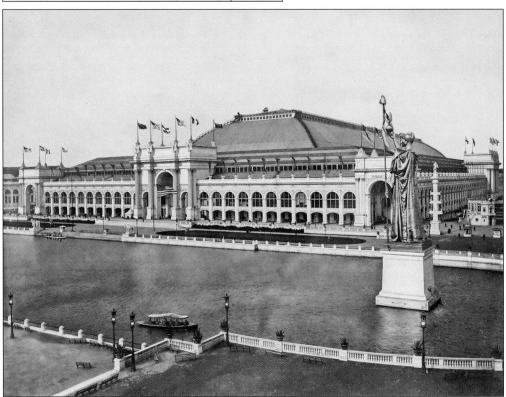

In 1890, Chicago was chosen to host the 1893 World's Columbian Exposition. This was less than 20 years after the city had virtually burned to the ground. When the exposition opened on May 1, 1893, it was the largest of any world's fair. Over 600 acres covering Jackson Park and the Midway Plaisance hosted over 200 buildings and 27.5 million paid visitors over the six months it was open. Pictured is the Manufacturers and Liberal Arts Building, which was so large it could have held over 23 football fields. (Ray Johnson.)

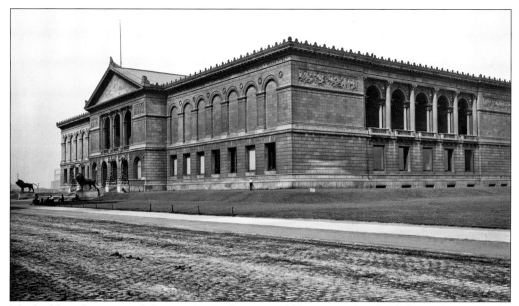

The building that currently houses the Art Institute of Chicago on South Michigan Avenue at the foot of Adams Street was built in 1892 and designed by architects Shepley, Rutan & Coolidge. It was originally built on the site of the Chicago Exposition Building to house the World's Congress Auxiliary of the World's Columbian Exposition. The Art Institute of Chicago paid for roughly half of the building with the understanding that following the exposition, it would be the new home of the Art Institute. (Courtesy Library of Congress, Detroit Publishing Company, LC-D4-12407.)

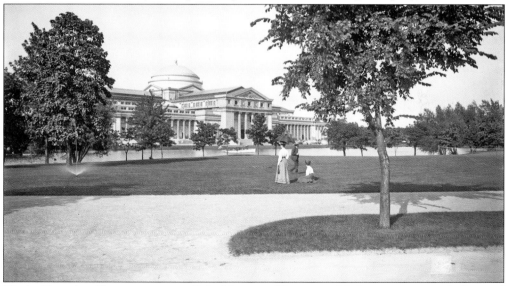

The building that Chicagoans now call the Museum of Science and Industry was originally designed by Charles B. Atwood as the Palace of Fine Arts for the 1893 World's Columbian Exposition. It housed priceless artwork from across the world, and following the exposition, became known as the Field Columbian Museum. The Field Museum moved into its current building in 1922, and after beautiful restoration paid for by Julius Rosenwald and bond issues from the South Park Commission, the Museum of Science and Industry opened during the 1933 Century of Progress Exposition. (Courtesy Library of Congress, Detroit Publishing Company, LC-D4-13266.)

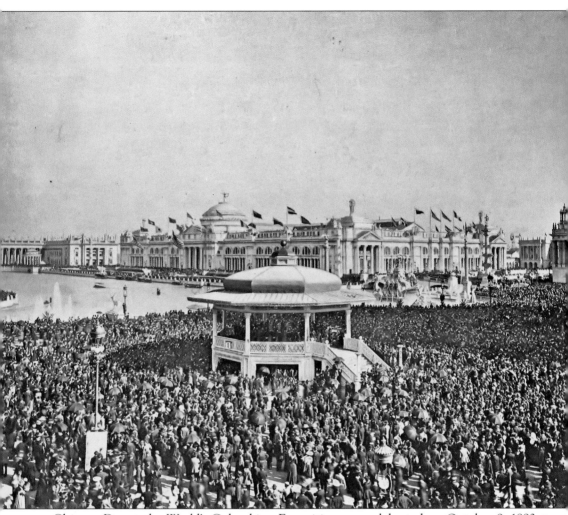

Chicago Day at the World's Columbian Exposition was celebrated on October 9, 1893, to commemorate the accomplishments of the citizens of Chicago merely 22 years to the day of the great fire. The fair broke all-time attendance records of any world's fair with a paid attendance of 716,881. Like the mythical Phoenix, Chicago had indeed risen from the ashes. (Ray Johnson.)

Five

PARAPHERNALIA OF FIRE

It has been over 145 years since the great fire destroyed much of the city of Chicago, and while it was devastating and people grieved over the loss of life, it also gave Chicago a second chance. The rebuilding of the city was a huge accomplishment and brought a new era of architecture and urban planning to the relatively young and inexperienced city.

The Chicago fire was so important an event in Chicago's history that it was given its own star on the Chicago flag. The other stars are for Fort Dearborn, the 1893 World's Columbian Exposition, and the 1933 Century of Progress Exposition.

But what remains that a resident or a visitor to Chicago can still see that harkens back to the three days that Chicago burned?

While there are obviously photographs in this book as well as a good number of artifacts at the Chicago History Museum, there are other reminders throughout the city that can be seen and even touched by those who choose to seek them out.

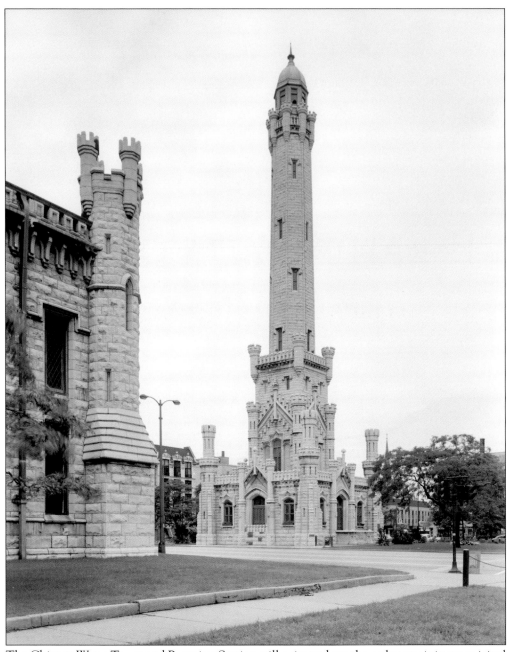

The Chicago Water Tower and Pumping Station still exist and are the only remaining municipal buildings from the Great Chicago Fire. The water tower is now an icon of Chicago's tenacity and is situated next to some of the most expensive real estate in the city along Chicago's Magnificent Mile. (Courtesy Library of Congress, HABS ILL, 16-CHIG, 43.)

The Second Presbyterian Church's first home was destroyed by the fire. The congregation had their last meeting in the church weeks before the fire. They had already vacated the building and started to plan this one farther south, which was finished in 1874 and stands today at the northwest corner of Michigan Avenue and Cullerton Street. (Courtesy Newberry Library, Second Presbyterian Church, Midwest MS Sloan Box 1, Folder 25.)

These altar chairs are from the Second Presbyterian Church's first building at the corner of Wabash and Washington Streets. While the church was destroyed by the fire, the altar chairs were out being repaired and survived the flames. The chairs are no longer used and are displayed in a vestibule. (Ray Johnson.)

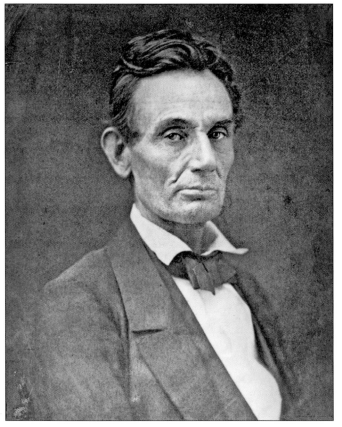

This photograph of Abraham Lincoln was taken at the Cooke and Fassett Studios in Chicago. The studio burned, along with the negative, but Cooke wrote to his partner on April 25, 1865, and stated, "Mrs. Lincoln pronounced [it] the best likeness she had ever seen of her husband." (Courtesy Library of Congress , LC-USZ62-11492.)

Along Clark Street in Lincoln Park sits what looks like a lawn ornament in front of the old Chicago Academy of Science Building. It is actually a finial from the top of the old Chicago City Courthouse, which burned in the fire of 1871. It is said that some half-dozen finials exist in different areas of the city. (Ray Johnson.)

This is another of the possible six finials that still exist from the Chicago City Courthouse. This one was collected by Seth Wadhams and placed on his property (now Wilder Park) in Elmhurst, Illinois. He supposedly had collected two of the finials after the fire as souvenirs, but only one remains. (Ray Johnson.)

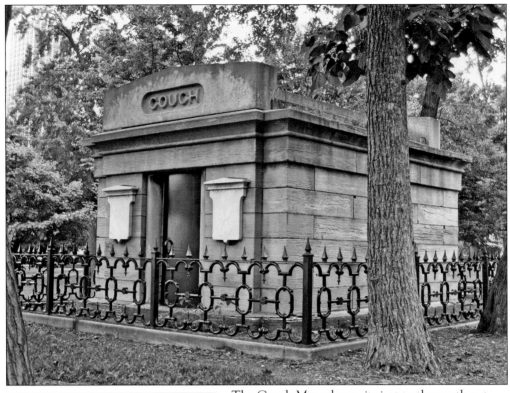

The Couch Mausoleum sits just to the northeast of the Chicago History Museum off LaSalle and Clark Streets. It is the only physical reminder that Lincoln Park used to be the Old Chicago City Cemetery in 1871 and survived the fire. Whether Ira Couch is still inside is a mystery. (Ray Johnson.)

The Chicago History Museum on Clark Street hides a relic of the fire in the bushes outside, just to the east of the museum. Inside the square opening is what is affectionately known as "The Blob." The Blob is the largest molten piece of metal left from a burned hardware store on Clark Street. (Ray Johnson.)

The Blob, pictured here, is actually pretty huge. The museum once thought about moving it inside, but after learning that it weighed approximately 48,600 pounds, twice the weight of the current Pioneer locomotive on display, and would collapse the floor of the museum, the idea was abandoned. (Ray Johnson.)

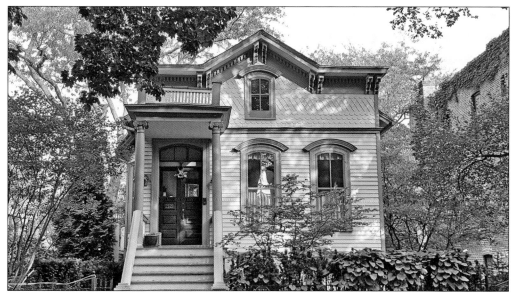

The frame house at 2121 North Hudson Street was saved from the fire by Chicago policeman Richard Bellinger. The story is told that he wet the house with water, and when the water ran out, he used cider. The home was designed by architect W.W. Boyington, who also created the Chicago Water Tower. It is now a private residence. (Ray Johnson.)

The blue frame house at 2339 North Cleveland Street in Chicago was built in 1866 and somehow survived the fire as it made its way northeast. It is a private residence and has a sister residence just to the north. (Ray Johnson.)

The brown frame house at 2343 North Cleveland Street is just north of the 2339 North Cleveland address, and for some reason, both cottages survived the fire. It is hard to believe that anything made of wood could have survived such an intense blaze. It is also a private residence. (Ray Johnson.)

St. Michael's Church stands at what is now Eugenie Street and Cleveland Avenue. It was started by the diocese in 1852 to serve the German immigrants in the area. The church was blessed and dedicated on September 29, 1869. Two years later, the church burned in the fire, but most of the walls remained and were used to become the first church to rise from the ashes. (Ray Johnson.)

"Exhibit Y"

Richard Cook
to
Ambrose L. Jordan

Filed for Record January
1st 1851, at 8 oclock A.M.

Know all men by these presents. Whereas, Allen Jordan of the Town of Seward in the County of Kendall and State of Illinois, did on the sixteenth day of November one thousand eight hundred and fifty execute to Richard Cook of Suffolk County in the State of New York, for the purpose of securing an anticipated loan, his bond or written obligation bearing date the day and year above mentioned, in the penal sum of two thousand dollars conditioned for payment of one thousand dollars in years with annual interest at six per cent and as additional security for the payment of said last mentioned sum of money, did also execute on the same day and year bearing the same date to the Richard Cook a certain indenture of mortgage, upon a certain farm or parcel of land supposed to contain one hundred and ninety five acres situate in the Town of Lisbon and Seward, in the said County of Kendall and State of Illinois, which said indenture of mortgage being duly acknowledged, was recorded in Book

This is the first page of a three-page document that is preserved by the Great Lakes Region of the National Archives and Records Administration. It is from the only remaining court case from the Chicago Federal Building, which was a complete loss in the fire of 1871. How it survived is a mystery. (Courtesy National Archives and Records Administration, Great Lakes Region.)

121

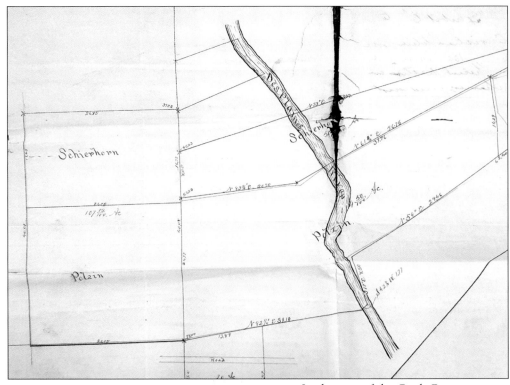

In the care of the Cook County Clerk of the Circuit Court Archives are the "Burnt Records." These records are not burnt themselves, but represent court cases filed when disputes arose about issues of land ownership after the fire. The cases start in 1872 and go well into the 1940s. They are a great resource for maps, deeds, and other records that would have been destroyed in the fire. (Courtesy Cook County Clerk of the Circuit Court Archives.)

Old St. Patrick's Church, at 700 West Adams Street in the West Loop, is the oldest public building in Chicago. It was dedicated on Christmas Day 1856 with Rev. Denis Dunne as its pastor. Reverend Dunne was also responsible for bringing the St. Vincent DePaul Society to Chicago. The fire of 1871 missed the church by only two blocks. (Courtesy Library of Congress Prints and Photographs Division, HABS ILL, 16-CHIG, 35—3.)

The Harvest Bible Church, as it is now called, stands at the southeast corner of Walton and Dearborn Streets. In 1871, it was known as Unity Church or Collyer's Church after its well-known pastor, Robert Collyer. It was designed by Theodore V. Wadskier and was mostly destroyed by the Great Chicago Fire. Most of the walls remained and are there today. (Ray Johnson.)

The Henry B. Clarke House is the oldest surviving home in Chicago and was built by Henry B. Clarke in 1836. Clarke came from New York with his wife, Caroline, and started the hardware business of King, Jones, and Company. Henry Clarke died in 1849 and his wife in 1860. The house was originally at Michigan Avenue and Seventeenth Street but is now at 1827 South Indiana Avenue. (Ray Johnson.)

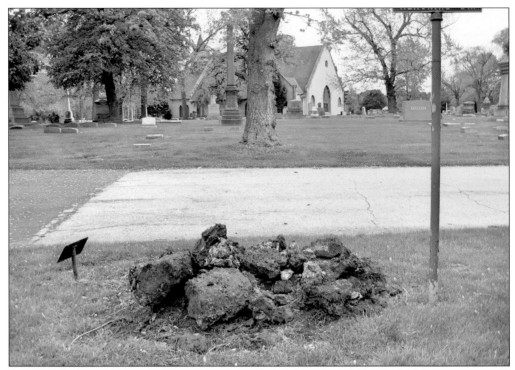

Oak Woods Cemetery, at 1035 East Sixty-Seventh Street, is one of Chicago's oldest cemeteries. It was established on February 12, 1853. Given the location of the cemetery, it is surprising it would have a relic of the Chicago fire, but near the entrance of the cemetery is a small marker with a large pile of what looks to be building remains from the fire of 1871. (Ray Johnson.)

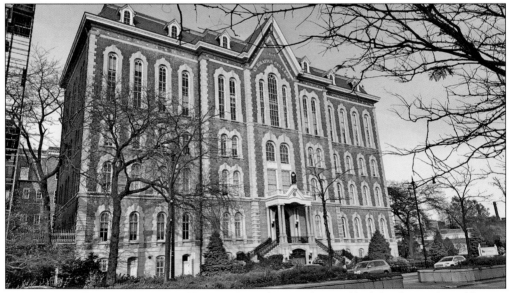

St. Ignatius College Prep's main building predates the 1871 fire, and luckily, the wind was blowing northeast or the building would probably not be there—it is only one mile due west of where the blaze started in the O'Leary barn. The building, finished in 1869, was designed by Canadian architect Toussaint Menard. (Ray Johnson.)

124

The Chicago Fire Academy sits on the exact spot where the O'Leary residence stood at the start of the Great Chicago Fire. Egon Weiner's representation of a flame stands just to the west of the entrance at Jefferson and DeKoven Streets. (Ray Johnson.)

This is a very long view of the Chicago Water Crib from the shore of Lake Michigan. It is a different crib than the one in 1871, but it is in the same spot and brings fresh water for Chicago's residents. The crib is two miles out from the shore, but the original was still endangered by flying embers. (Ray Johnson.)

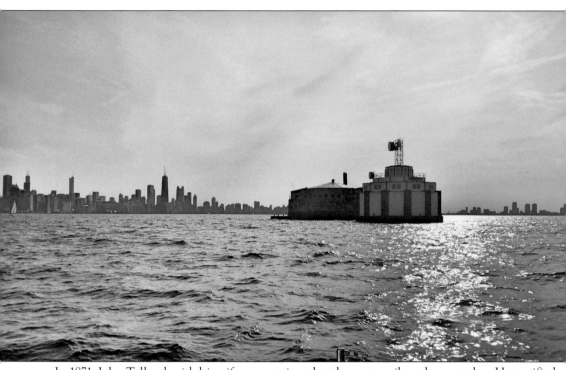

In 1871, John Tolland, with his wife, was stationed at the water crib as the caretaker. He testified after the fire that he spent many frantic hours on October 9, 1871, extinguishing embers and flames landing on the roof of the crib. That means the Great Chicago Fire extended at least two miles out into Lake Michigan. This is Chicago's current water crib, still two miles out into the lake. (John Boda.)

BIBLIOGRAPHY

Bales, Richard F. *The Great Chicago Fire and the Myth of Mrs. O'Leary's Cow*. Jefferson, NC: McFarland & Company, 2002.

Charles River Editors. *The Deadly Night of October 8, 1871: The Great Chicago Fire and the Peshtigo Fire*. Charleston, SC: CreateSpace Independent Publishing, 2015.

Chicago Historical Society. *The Great Chicago Fire*. Chicago, IL: Rand McNally & Co., 1971.

Cromie, Robert. *The Great Chicago Fire*. Nashville, TN: Rutledge Hill Press, 1958 and 1994.

Dybwad, G.L., and Joy V. Bliss. *Chicago Day at the World's Columbian Exposition*. Albuquerque, NM: The Book Stops Here, 1997.

Gess, Denise, and William Lutz. *Firestorm at Peshtigo: A Town, Its People, and the Deadliest Fire in American History*. New York, NY: Owl Books, 2002.

Miller, Ross. *The Great Chicago Fire*. Urbana and Chicago, IL: The University of Illinois Press, 1990.

Murphy, Jim. *The Great Fire*. New York, NY: Scholastic, 1995.

Pack, William. *The Essential Great Chicago Fire*. Charleston, SC: CreateSpace Independent Publishing, 2014.

Sawislak, Karen. *Smoldering City: Chicagoans and the Great Fire 1871–1874*. Chicago, IL: The University of Chicago Press, 1995.

Waskin, Mel. *Mrs. O'Leary's Comet: Cosmic Causes of the Great Chicago Fire*. Chicago, IL: Academy Chicago Publishers, 1985.

DISCOVER THOUSANDS OF LOCAL HISTORY BOOKS FEATURING MILLIONS OF VINTAGE IMAGES

Arcadia Publishing, the leading local history publisher in the United States, is committed to making history accessible and meaningful through publishing books that celebrate and preserve the heritage of America's people and places.

Find more books like this at
www.arcadiapublishing.com

Search for your hometown history, your old stomping grounds, and even your favorite sports team.

Consistent with our mission to preserve history on a local level, this book was printed in South Carolina on American-made paper and manufactured entirely in the United States. Products carrying the accredited Forest Stewardship Council (FSC) label are printed on 100 percent FSC-certified paper.

MADE IN THE USA